Visions of Venice

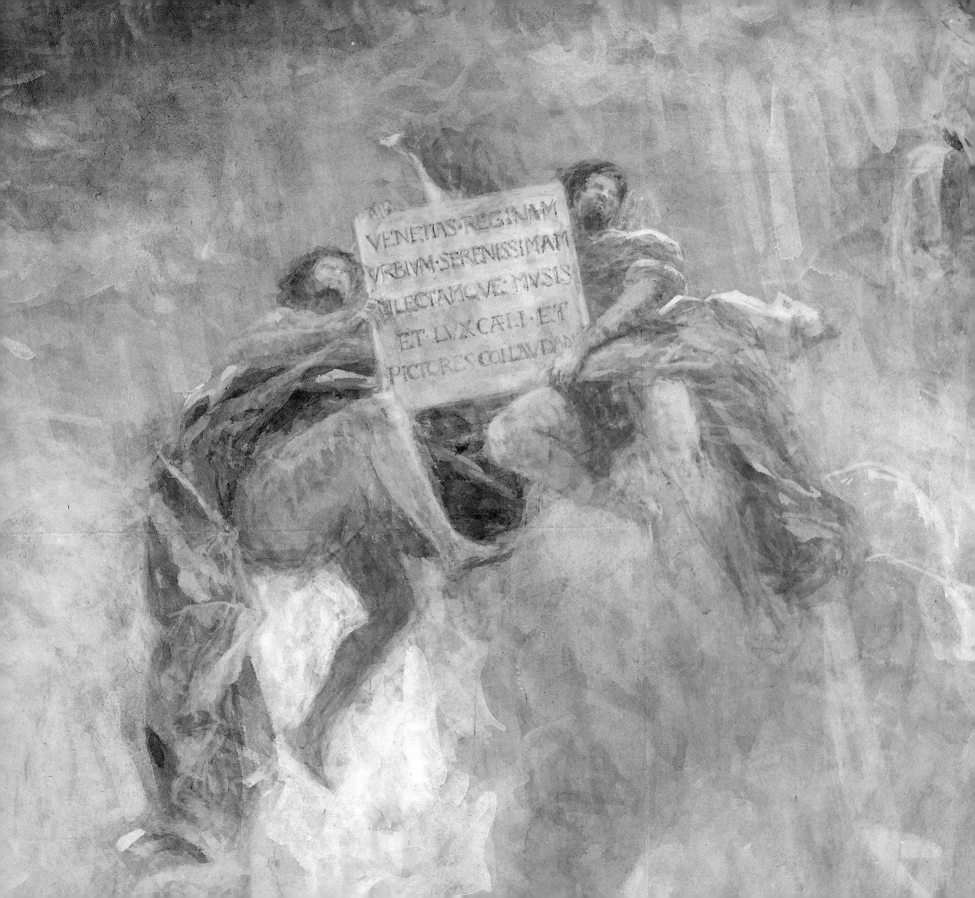

VISIONS *of* VENICE

Michael Spender

DAVID AND CHARLES

Newton Abbot London

Frontispiece:
Jacqueline Rizvi
Venetian Apotheosis, detail

For Helen and Haddon

British Library Cataloguing in Publication Data
Spender, Michael
 Visions of Venice.
1. British water-colour paintings. Special subjects. Venice
 I. Title
 758.74531

 ISBN 0–7153–9789–3

Typeset by John Youé on a Macintosh system
and printed in Singapore
by C.S.Graphics Pte. Ltd
for David & Charles Publishers plc
Brunel House Newton Abbot Devon

ACKNOWLEDGEMENTS

My appreciation is absolute in thanking the artists
whose work features in the pages of this book. Their
marvellous watercolours were one of the reasons for
embarking on this project; the other was the remark-
able hold that Venice has on the imagination of all of
us, including this writer.

 That the city survives to inspire us is due in
great part to the activities of the Venice in Peril Fund.
I am extremely grateful to VIP's Chairman, Lord
Norwich, who has written the Foreword to this book.

 Every writer needs a sympathetic editor, and
this Faith Glasgow has most certainly been. My idea
for this project was cemented during a conversation
with Tom Northey of Pirelli, and his support has been
very welcome.

 Helen Spender spent more time reading and
correcting my text than I did. For putting up with that
and with me while writing, as well as for her participa-
tion in the whole project, she deserves all my thanks.

CONTENTS

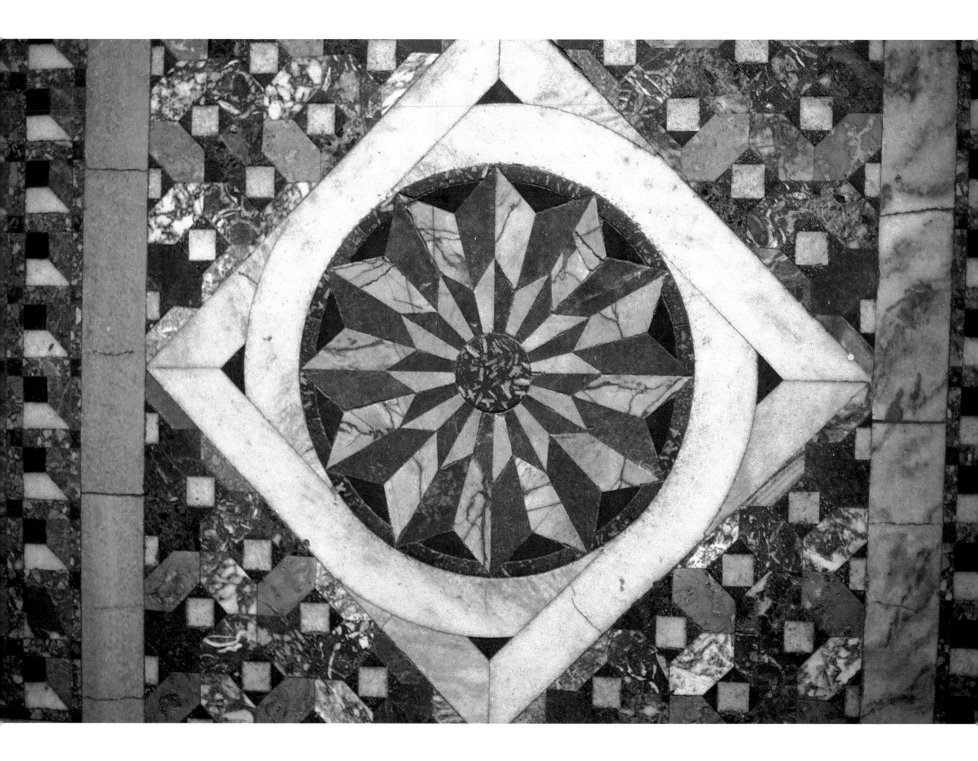

FOREWORD

If Venice had not been an independent republic for a thousand years; if she had not been mistress of a commercial empire extending across the known world as far as India and even China; if she had not evolved the most sophisticated and successful system of government that Europe had ever seen; if she had not inspired some of the most glorious music ever written and invented opera; then one might have been tempted to think that she had been created specially, specifically, for painters. After all, where else on earth can provide such dazzling architecture, such magical effects of light, or — no small consideration in the latter half of the twentieth century — such freedom from that greatest of all scourges to every other city, the motor car?

Or such a magnificent artistic tradition of her own? The Venetians cannot admittedly be credited with the invention of town painting: that honour must belong, I suppose, to the Gothic painters of France and Flanders. But it was Gentile Bellini, Vittore Carpaccio and their followers, at the end of the fifteenth century and the beginning of the sixteenth, who raised that particular art to new heights — as a visit to that tremendous cycle of paintings in the Accademia depicting the Miracles of the True Cross establishes beyond all doubt. The only mystery to me is why, with such splendid examples before them, the later painters of the *cinquecento* should have so ignored their surroundings: after Carpaccio, there is hardly a single Venetian view-painter worthy of the name until the appearance of Vanvitelli (really a Dutchman, van Wittel) and Luca Carlevaris in the 1690s, the harbingers of the golden age of the *vedutisti* — led by Canaletto and Francesco Guardi.

Since then, there has been no shortage of painters in Venice; but few oil painters, it seems to me, of any real quality. High above them all looms the gigantic figure of J.M.W. Turner: but much of his most inspired Venetian work is in watercolour, and that brings me to a favourite theory of mine — that Venice is essentially a watercolour city, a city whose glint and shimmer no other medium can capture so well.

With this book, my point is proved. It remains for me only to express the gratitude of the Venice in Peril Fund to the Royal Watercolour Society, to its secretary Michael Spender and to all the artists represented within its pages, for this spectacular tribute to the most miraculous of cities — and for their support in our efforts to ensure its survival, so that future generations will be able to celebrate it — with any luck — as brilliantly as they have themselves.

John Julius Norwich

Opposite
Marble paving inside the
north-west porch of the
Basilica San Marco

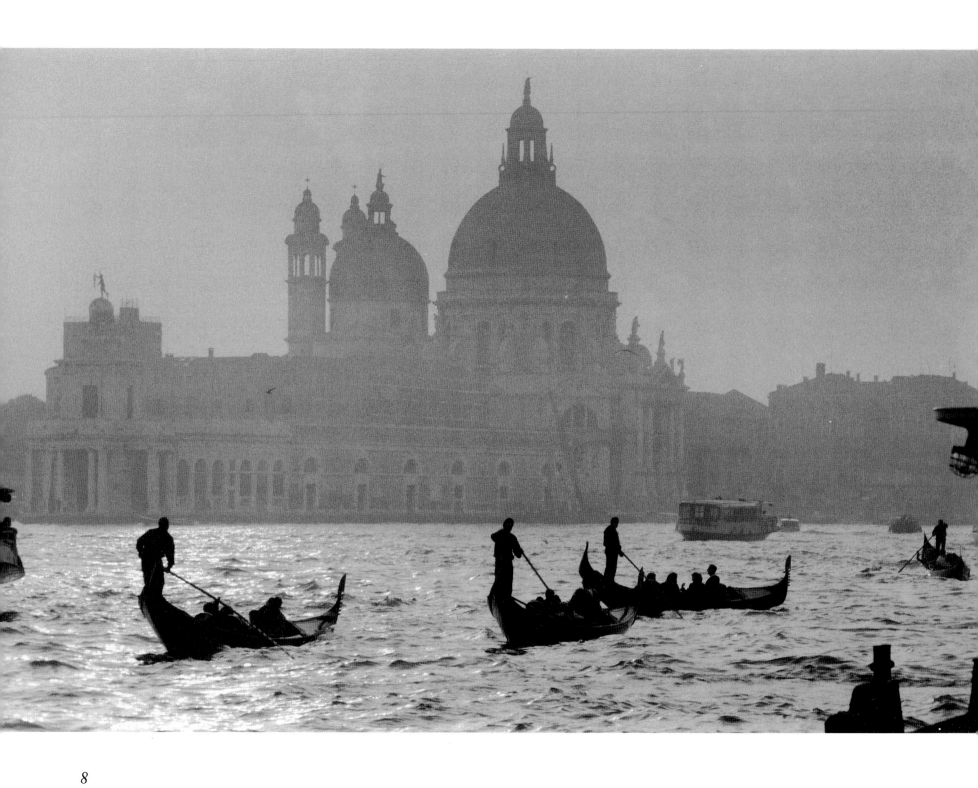

INTRODUCTION

There is more than one way to arrive in Venice. There is the *motoscaffo* – the water taxi – south across the Lagoon from Marco Polo airport. Venice rises out of the water, rather as it did for travellers of previous centuries arriving in the Lagoon from the northern stretches of the Gulf of Venice: a similar image of the city would have emerged on the gondola rides from Chioggia and Mestre. There is the autostrada, straight as an arrow from Padua to Marghera and Mestre, where a road branches off and joins with the railway to cross the Lagoon bridge, leading to the Piazzale Roma and the nearby Santa Lucia station. Then there is the journey to the Venice of the mind – for we each hold a mental picture of the city, which may or may not be updated the first time we make a physical appearance there. This momentous shared image of Venice is a lasting inheritance of western culture.

Venice is a remarkable city, separating water and sky. It lies in the Laguna Veneta – around 230 square miles (600km^2) of sea water – protected from the Adriatic tides by a thin strip of islands, or *lidi*, between which are three vulnerable inlets. Some twenty thousand buildings sit on many millions of wooden piles, sunk through the mud of 118 islands into the more solid clay of the lagoon bed. As it now presents itself, Venice would be a cliché, almost a stage set of a city if anyone had invented it in one fell swoop; but of course Venice has as venerable a history as any of the world's great piecemeal architectural conglomerations. From the rise of the city – through the two centuries of Empire after 1380 to absorption within the Kingdom of Italy in 1866 – evolved a complex pattern of major and minor masterpieces of western and eastern architecture amid the everyday buildings of a north Italian city.

This book illustrates contemporary interpretations of this unique urban environment. The history of Venice and Venetian art are not our concern. Some impressions of the city, recorded by overseas visitors over the centuries, will, however, help to provide a setting for the discussion of the contemporary images that are reproduced here. These impressions are literary rather than visual, for the history of British watercolours of Venice is surveyed excellently elsewhere – notably in the catalogue of the exhibition held at the Bankside Gallery, London, in 1990.

Nearly all of the works illustrated have been painted as a result of direct study of the subject. One picture, however, has emerged from an experience of the Venice of the mind, of the city that has so brilliantly informed the intellect of the post-medieval world. Jacqueline Rizvi has taken the opportunity to create a

Opposite
Santa Maria della Salute
from the Molo

Below
Gregory Alexander
STUDY FOR REGATTA – VENICE
Outlining the pageantry of the
Republic revived

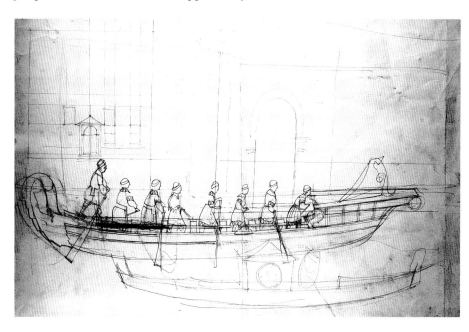

major allegorical watercolour, *Venetian Apotheosis*. This majestic work depicts artists being led to the Venice of Jacqueline's imagination – the Venice that is common to all of us, a pinnacle of culture, a visual and aural wonder, a shared home of light.

This apotheosis evokes Byron's lines in Canto IV of his epic poem *Childe Harold's Pilgrimage*, finished in 1818:

> I loved her from my boyhood; she to me
> Was as a fairy city of the heart,
> Rising like water-columns from the sea,
> Of joy the sojourn, and of wealth the mart;
> And Otway, Radcliffe, Schiller, Shakespeare's
> art,
> Had stamp'd her image in me, and even so,
> Although I found her thus, we did not part;
> Perchance even dearer in her day of woe,
> Than when she was a boast, a marvel, and a
> show.

Byron's eventual acquaintance with the decaying buildings of the post-Napoleonic city came early during the influx of pilgrims from Europe and America that was to flood Venice as thoroughly as its high tides. Impressed by its beauty, its richness and its ambiguities, many of these foreigners – *forestieri* to the Venetians – recorded their impressions of a destination that rapidly became the travel writer's El Dorado. William Hazlitt, for example, wondered at the place in his *Notes of a Journey through France and Italy*, published in 1826:

> Venice is loaded with ornament, like a rich city-heiress with jewels. It seems the natural order of things. Her origin was a wonder: her end is to surprise. The strong, implanted tendency of her

genius must be to the showy, the singular, the fantastic. Herself an anomaly, she reconciles contradictions, liberty with aristocracy, commerce with nobility, the want of titles with the pride of birth and heraldry. A violent birth in nature, she lays greedy, perhaps ill-advised, hands on all the artificial advantages that can supply her original defects. Use turns to gaudy beauty; extreme hardship to intemperance in pleasure. From the level uniform expanse that forever encircles her, she would obviously affect the aspiring in forms, the quaint, the complicated, relief and projection. Her eye for colours and costume she would bring with conquest from the East. The spirit, intelligence, and activity of her men, she would derive from their ancestors: the grace, the glowing animation and bounding step of her women, from the sun and mountain-breeze!

Such luscious praise did not and could not go on indefinitely, especially considering the sorry state of the city for much of the nineteenth century. Of equal discouragement would have been the sheer volume of writing produced – sufficient for Henry James to feel bound to introduce his chapters on Venice in *Italian Hours* (published in 1909) as follows:

> It is a great pleasure to write the word; but I am not sure there is not a certain impudence in pretending to add anything to it. Venice has been painted and described many thousands of times, and of all the cities of the world is the easiest to visit without going there. Open the first book and you will find a rhapsody about it; step into the first picture-dealer's and you will find three or four high-coloured 'views' of it. There is

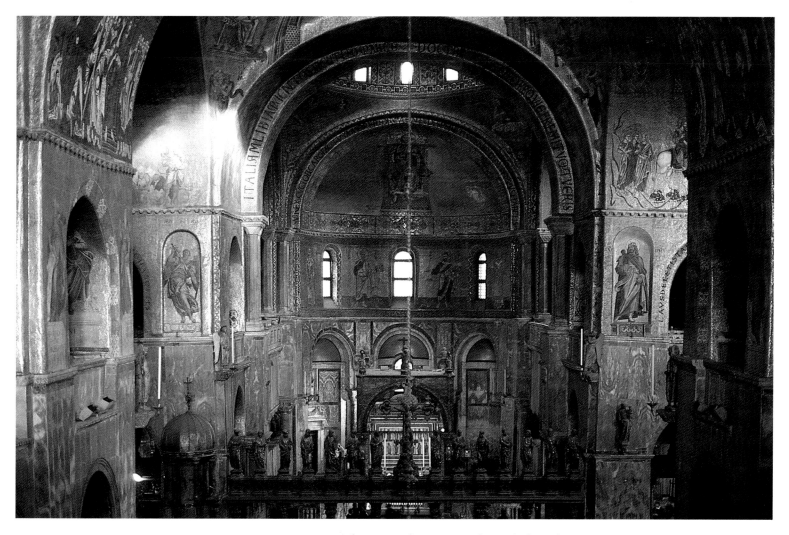

notoriously nothing more to be said on the subject. Every one has been there and every one has brought back a collection of photographs. There is as little mystery about the Grand Canal as about our local thoroughfare, and the name of St. Mark is as familiar as the postman's ring. It is not forbidden, however, to speak of familiar things, and I hold that for the true Venice-lover Venice is always in order.

There is nothing new to be said about her, certainly, but the old is better than any novelty. It would be a sad day indeed when there should be something new to say. I write these lines with the full consciousness of having no information whatever to offer. I do not pretend to enlighten the reader; I pretend only to give a fillip to his memory; and I hold any writer sufficiently justified who is himself in love with his theme.

Interior of the Basilica
San Marco, from the gallery

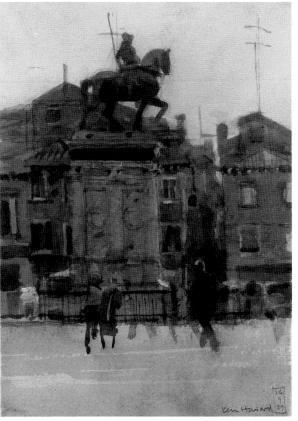

Ken Howard
Campo Santi Giovanni
e Paolo
This watercolour shows the great equestrian monument to the condottiere, *Bartolomeo Colleoni, modelled by Verrocchio in 1479 to 1483. One of the most glamorous figures of the Republic, Colleoni commanded its army and left a fortune to the city on his death in 1475*

While few prose writers share James' powers of perception or description, many would undoubtedly concur with his compunction in attempting to write about Venice. Whether the passage of about a century since James wrote these words has made the task any harder is perhaps open to doubt, for by the last decades of the nineteenth century Venice had long been a shrine for the cultured tourist. This was particularly true with English speakers who flocked to the city in the later part of the century, the words of John Ruskin on their lips, the paintings of J. M. W. Turner in their minds and either *Murray's* or *Baedeker's* guidebook to hand.

Although some foreign visitors travelled to Venice and witnessed the final years of the Serenissima – the Most Serene Republic – in the eighteenth century, this substantially Gothic city was less of a priority for neo-Classical Europe than the Ancient and Renais-

sance glories of Rome, Florence or Naples. From the rise of Napoleon in the 1790s until the fall of the French Empire at Waterloo, the Continent and in particular the distant El Dorado of Italy, were largely closed to the British.

In Venice the occupying French authorities shut or desecrated many churches, monasteries and guilds, and demolished considerable areas of the city to make way for public gardens and processional streets. Having previously been in occupation some nine years earlier, the Austrians recaptured the city in 1814, following a lengthy siege. Under the Treaty of Vienna the city was formally assigned to them. The Venice that the occupying army discovered was one of desolation and decay. But the destruction and dereliction that did take place was not sufficient to alter indelibly the character of the city. Indeed it was as much as anything the romantic decay of a once imperial metropolis that attracted early nineteenth-century travellers like Samuel Rogers, whose series of poems entitled 'Italy' gave a clarion call to painters like Turner, Richard Parkes Bonington and Samuel Prout.

Following the example of Rogers, Prout started to popularise Venice in his illustrations for travel books of the 1830s. In the next few years, Prout's fellow members of the 'Old', later Royal, Watercolour Society, and many other artists began to include Venice on their itineraries. They were driven as much as anything by the realisation that the romantic decay and faded glory of the city appealed to patrons back home. Paintings of Venice sold. Prout and Turner were followed by a list of painters and draughtsmen that reads like a catalogue of nineteenth-century topographical artists. By the mid-century it seems to have become *de rigueur* for the members of the Society to have Venice in their repertoire – William Callow, James Duffield Harding, James Holland, George Price

Boyce, Albert Goodwin, Arthur Melville and John Singer Sargent, some of them guided there by Ruskin, are just a few of the many who were to pay homage.

Venice became a milieu for writers even sooner than it did for painters. Byron was entranced by the crumbling glory of the Gothic city, relating to his friend Thomas Moore that 'I have been familiar with ruins too long to dislike desolation'. In the midst of a time of characteristically Byronic pleasure-seeking, he was inspired to write much poetry. In Canto IV of *Childe Harold's Pilgrimage* he berated the Austrian occupation and points a warning finger in the direction of his homeland:

> Thus, Venice, if no stronger claim were thine,
> Were all thy proud historic deeds forgot,
> Thy choral memory of the Bard divine,
> Thy love of Tasso, should have cut the knot
> Which ties thee to thy tyrants; and thy lot
> Is shameful to the nations – most of all,
> Albion! to thee: the Ocean queen should not
> Abandon Ocean's children; in the fall
> Of Venice think of thine, despite thy watery wall.

This moral tone combined happily for Byron with the amorous adventures and the indulgent lifestyle that he cultivated in Venice. He adored traversing the city in his gondola, although – as he suggested in 'Beppo: A Venetian Story', of 1818 – the craft was not purely used as a means of transport:

> And up and down the long canals they go,
> And under the Rialto shoot along,
> By night and day, all paces, swift or slow,
> And round the theatres, a sable throng,
> They wait in their dusk livery of woe, –
> But not to them do woeful things belong,
> For sometimes they contain a deal of fun,
> Like mourning coaches when the funeral's done.

In 1818 Shelley came to Venice. He enjoyed the gondola trips arranged for him by Byron, as well as riding with his friend along the shore of the Lido – the principal stretch of land protecting the Lagoon – which at the time was the nearest countryside. He alluded to such an excursion in his 1818 poem 'Julian and Maddalo':

> I rode one evening with Count Maddalo
> Upon the bank of land which breaks the flow
> Of Adria towards Venice: a bare strand
> Of hillocks, heaped from ever-shifting sand,
> Matted with thistles and amphibious weeds,
> Such as from earth's embrace the salt ooze breeds,
> Is this; an uninhabited sea-side,
> Which the lone fisher, when his nets are dried,
> Abandons; and no other object breaks
> The waste, but one dwarf tree and some few stakes
> Broken and unrepaired, and the tide makes
> A narrow space of level sand thereon,
> Where 'twas our wont to ride while day went down.

Wilfred Fairclough
PALAZZI ON THE GRAND CANAL, WITH GONDOLAS PASSING
Using the natural red chalk that he describes in his interview to great effect, the artist has here caught both the sense of light being thrown up from the water and the movement of the gondolas

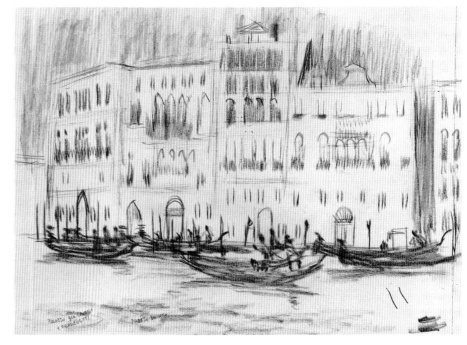

Lorna Binns
O Sole Mio!
*All kinds of fun may be had in
a gondola, especially when the
sun is shining*

On a breezy November day, the miles of beach deserted and the Adriatic rollers crashing onto the vast expanse of undisturbed sand, one can get a sense of the Lido Shelley knew. Nowadays, however, the Lido is a busy seaside resort and its private beaches are dominated by the Hotel des Bains, the setting for Thomas Mann's novella, *Death in Venice*. The intense contrast with the stone, brick and plaster of Venice (and the islands immediately to its north) has led to the long green island of the Lido becoming a popular element of Venetian life in the summer months.

Maurice Sheppard's watercolour of a typical Lido villa garden, reproduced here, captures that greenness of the island, which comes as such a surprise after a time in Venice – almost as great a surprise as the cars that whisk down its long straight roads. In fact, Venice is secretly verdant itself, but one has to seek out private courtyards and gardens to discover quite how much more there is than the ubiquitous planted urns. On the Lido there seems less need for possessive secrecy and the gardens of the summer villas are resplendent for all to see, as Maurice suggests in his watercolour.

Extensive building work has transformed the Lido since the late nineteenth century. By that time, available building land in Venice itself was only a long distant memory. It seems extraordinary, but it is in part because of its unparalleled geographical constraints that this city remains more or less intact. Most other north Italian cities were capable of expanding outwards, creating industrial suburbs. Those that did would often find their older, central quarters being redeveloped to match the growth in production and ancillary services. The least restlessness to emulate the great building projects of Milan and other Italian cities, and Venice would be in danger of imploding.

Thus, Venice could not equal the transition to industrialisation in the nineteenth century made by other great mercantile cities. Even if there had been more available land, any thoughts of expansion that the Republic might have had were laid to rest when its international power was yielded to Napoleon in 1797 by the last doge, Lodovico Manin. It was not until the twentieth century and the creation of industrial zones on what we would now call green-field sites that the economic benefits and environmental hazards of large-scale production came to the shores of the Lagoon.

By the middle of the nineteenth century, with political as well as industrial revolution altering the face of Europe, Venice itself was afflicted by rebellion, siege and reoccupation, before finally being incorporated within the Kingdom of Italy in 1866. During this

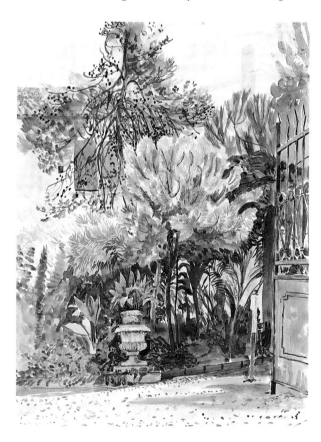

Maurice Sheppard
Villa Garden on the Lido
Predominantly a painter of nature, this past-President of the Royal Watercolour Society has sought out a verdant corner of the Lido

Olwen Jones
VENETIAN ROOF-TOPS, FROM
THE HOTEL SERENISSIMA
*Sometimes it seems like the
only way to get a breath of air*

16

period of turmoil the message of conservation was already being promoted in the city by anxious observers of apathy and neglect, such as Ruskin. Whatever the indifference and incompetence that has on several occasions threatened, or, even worse, sometimes removed major landmarks since that time, the spirit of the place has remained. This we can readily appreciate by surveying part of the great body of topographical art that has come down to us. Provided the great conservation projects currently under way continue apace there are reasons to believe that Venice will remain for succeeding generations to visit, to record and to rhapsodise over.

Ruskin felt less than confident about the city's likelihood of survival. His great work of documentation and proselytism, *The Stones of Venice*, was written, illuminated and published, in 1853, with a sense of urgency. Venice, the surviving successor to Tyre, once 'the garden of God',

...is still left for our beholding in the final period of her decline: a ghost upon the sands of the sea, so weak – so quiet – so bereft of all but her loveliness, that we might well doubt, as we watched her faint reflection in the mirage of the lagoon, which was the City, and which the Shadow.

I would endeavour to trace the lines of this image before it be for ever lost, and to record, as far as I may, the warning which seems to me to be uttered by every one of the fast-gaining waves, that beat like passing bells, against the STONES OF VENICE.

In his 'Ode on Venice', of 1818, Byron had already shown that he recognised the fate that could become the city. He also presaged the great international response to its plight that was to follow flooding in 1966 and 1967:

Oh Venice! Venice! when thy marble walls
　Are level with the waters, there shall be
A cry of nations o'er thy sunken halls,
　A loud lament along the sweeping sea!
If I, a northern wanderer, weep for thee,
What should thy sons do? – anything but weep:
And yet they only murmur in their sleep.

By the 1960s it was becoming appreciated that the city was being attacked from all three fundamental sources – the sea, the air and the land. The rising water levels of the Mediterranean – extreme when the southeasterly sirocco drives the high tide before it into the landlocked north Adriatic – were increasing the frequency of the polluted and damaging *acqua alta*, or high water. Venetian buildings and monuments were suffering acutely from the air-borne pollution emanating from the industrial plants on the shores of the Lagoon. Particularly corrosive had been the suspension of sulphur dioxide in the salty damp atmosphere that is characteristic of the city. The industry of Porto

Sir Hugh Casson
Snow Flurry – Lagoon

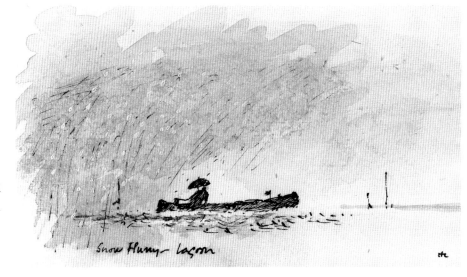

Snow Flurry – Lagoon

Marghere and Mestre was also responsible for subsidence in the Lagoon: as the factories devoured fresh water from artesian wells beneath the Lagoon, so the sea-bed had begun to sink.

It was the terrible floods, the abnormal *acqua alta*, of November 1966 that finally confirmed to public consciousness that Venice was in danger of sinking on its rotting larch piles into the mud and clay of the Lagoon. A worldwide appeal was launched under the auspices of UNESCO and some thirty national governments and voluntary organisations formulated plans to aid the restoration and preservation of the city, its buildings and works of art.

In Britain the Venice in Peril Fund was formed in 1971, under the guidance of the former ambassador to Italy, Sir Ashley Clarke. This organisation was the successor to the Italian Art and Archives Rescue Fund, which had itself been established immediately after the floods. Venice in Peril's restoration projects have included Sansovino's Loggetta, at the base of the Campanile, and, most successfully, such important monuments as the church of Madonna dell'Orto, San Nicolo dei Mendicoli and the Porta della Carta, the magnificent entrance to the Palazzo Ducale. With the support of charitable contributions the fund's crucial work continues alongside efforts from organisations in over twenty countries.

One of the most symbolically significant res-

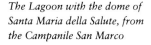

The Lagoon with the dome of Santa Maria della Salute, from the Campanile San Marco

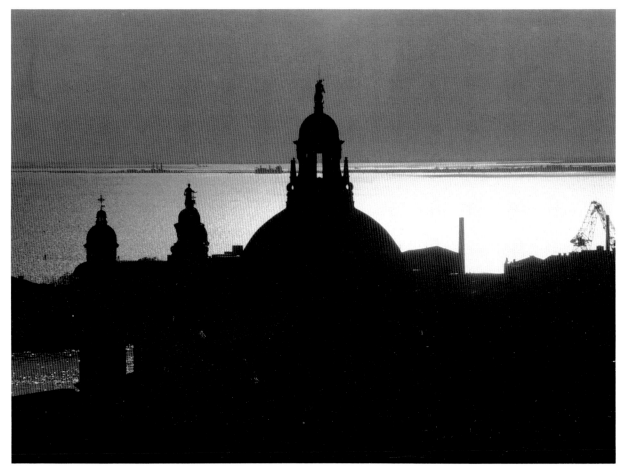

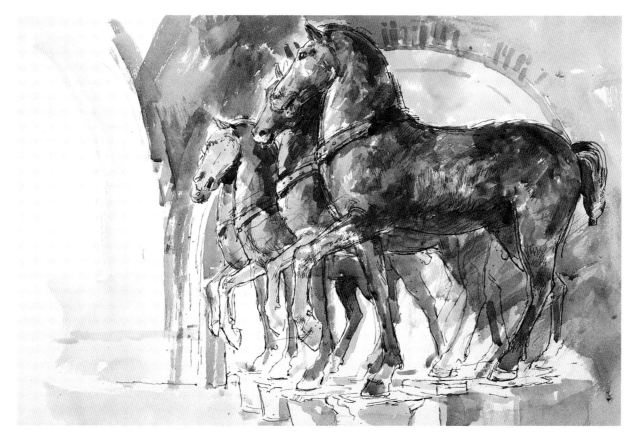

Pamela Kay
THE BRONZE HORSES OF
SAN MARCO

toration projects of recent years has been the attempt to preserve the four great bronze horses of San Marco from the harmful effects of weather, air-pollution and pigeons – all of which they have suffered during their occasionally interrupted six centuries of residence on the west front of the Basilica. The significance of their setting on the façade is made clear if we consider first the importance to the Venetians of the Basilica San Marco itself.

Originally founded in c830, this eleventh-century Byzantine church is the most venerable building in Venice, although it only became the city's cathedral in 1807. The west front is divided into five rounded portals, each surmounted by mosaics. In a unique aesthetic arrangement, these portals are in turn crowned by the unprecedented array of domes. To Ruskin, the west front was '...as a piece of rich and

fantastic colour, as lovely a dream as ever filled human imagination'. The Basilica was central to Ruskin's Venetian studies. It is in some degree to his credit that the façade was largely protected from the over-zealous restoration work which afflicted the rest of the building in the mid nineteenth century.

Actually made of an alloy of copper with silver and gold, the horses were recovered from the Hippo-drome in Constantinople and taken to the Venice Arsenale in the early thirteenth century. Seen as representing the Venetian Republic, they were later positioned in their prestigious setting on the façade of the Basilica. With many other spoils, Napoleon carried them off to decorate the Arc du Carrousel in the Tuileries. Soon after being reinstated in 1815, the horses were seen by Byron and described in Canto IV of *Childe Harold's Pilgrimage*:

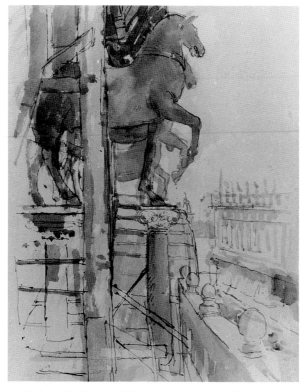

Before St Mark still glow his steeds of brass,
Their gilded collars glittering in the sun;
But is not Doria's menace come to pass?
Are they not *bridled*? – Venice, lost and won,
Her thirteen hundred years of freedom done,
Sinks, like a seaweed, into whence she rose!
Better be whelm'd beneath the waves, and shun,
Even in destruction's depth, her foreign foes,
From whom submission wrings an infamous
 repose.

 Byron was following Venetian tradition in seeing the horses as potent symbols of the city's status and freedom. One imagines, however, that the occupying Austrian forces would not have welcomed the poet's depiction of their bridled state. They remained, their glow presumably waning gradually, throughout the remainder of the nineteenth century, before again being taken down for safe keeping during both world wars.

 Eventually, in the 1970s it was finally decided to remove the horses from their vulnerable home on the façade. They were restored with the aid of Olivetti, who toured one of them in a fascinating exhibition to a number of cities, including London. Now, looking absolutely majestic – although not totally isolated from environmental damage in a room behind their previous position – these great survivals of Ancient Roman sculpture convey a life-enhancing power that is unfortunately lacking in the replicas which have stood rather stiffly outside since 1979. In her watercolour sketch of the replicas, and the finished picture of the horses in their indoor setting, Pamela Kay captures the spirit of these great symbols of Venice as they are now presented.

 In more general terms, much is being done to preserve the city. Recently the Italian authorities have spent large sums on restoration of buildings and monuments. More fundamentally they have imposed legislation intended to reduce pollution in the Lagoon, although the imposition of controls on atmospheric emissions has been a lengthy process. Subsidence has been halted with the construction of fresh water aqueducts supplying the city and the industrial zone. Following the first scientific study of the natural mechanics of the Lagoon, the largest project of all involves a consortium of international companies in the construction of a series of barriers to protect Venice from the high Adriatic tides which caused the floods of 1966.

 In recent years the intrusion of evil-smelling seaweed and the algae emanating from the polluted waters of the Po estuary have brought additional problems for those striving to save the city. Nevertheless, the effects of global warming notwithstanding, we hope we can at last begin to feel that Venice is to be preserved from the elements. Whether it can cope with

the erratic washes created by water taxis and other motor boats – which could be controlled – and the increasing wear and tear that the areas around San Marco and the Rialto receive from the expanding army of tourists – which might have to be limited – is another matter. The human invasion is the most feared. Due to finite available capacity and because of the comparative ease of monitoring access points to the islands, the Venetian authorities may soon be forced to make theirs the first of the world's major tourist cities to impose some form of visitor restrictions.

Although areas of Venice are now habitually crowded in the long tourist season, there have been times of war in the twentieth century when the city was again inaccessible to British visitors. Whether this was a contributory factor, or as a result of the long glut of Venetian pictures on the home market that Henry James describes, the ritual painting of Venetian views seems to have become less pervasive during our century. Perhaps it really was true that there seemed to be little further to say about the city.

This book is intended to reflect what appears to have been a revival of interest in Venice among serious figurative artists over the last two decades or so. It seemed appropriate to ask twenty-five members

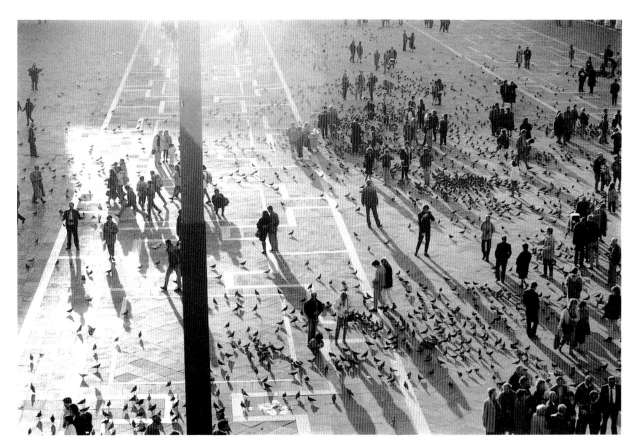

Pigeons and tourists in Piazza San Marco, from the roof of the Basilica

of the Royal Watercolour Society – artists working in the medium long considered ideal for recording Venice's watery charms – to produce a series of major pictures of their personal visions of Venice.

Most of the participants were chosen because of their existing interest in the subject. Others were asked to participate in order to discover how they would react on first visiting Venice and how they would accommodate the city into their work. As much as anything it would be interesting to find out how they would cope with the confrontation between the Venice of the mind, which Jacqueline Rizvi was to depict, and

their first sight of its reality. Would the ghosts of Turner, Whistler, Sargent and Sickert become the artists' muses, or would their omnipresence be too overwhelming for original creativity to thrive? This question was to receive some fascinating responses.

The project was an engaging and sometimes surprising exercise in looking at this beautiful city through twenty-five very different pairs of eyes. The number of artists commissioned was only limited by available space and, more importantly, the possibilities of seeing and discussing their visions of Venice personally. Although they are at the pinnacle of their

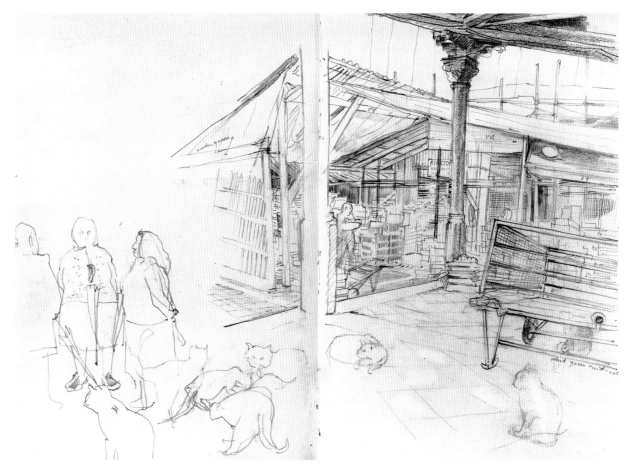

Olwen Jones
RIALTO MARKET WITH CATS
This large sketchbook drawing reveals the splendid draughtsmanship of the artist. Working quickly, she was even able to catch the posture of the figures who, for a short time, completed the composition

profession, these twenty-five are simply a microcosm of the legion of watercolourists painting Venice.

In spite of the worldwide increase in overseas tourism, there is no question that the inhabitants of Britain retain their position among the world's most multifarious cultural tourists. What more conveniently accompanies their expeditions than those traditional tools of the travelling professional and amateur artist – the watercolour box, pad, pencil, brush and water-pot? The proliferation in exhibitions of watercolour paintings depicting scenes from Calais to China and from Moscow to the South Pacific is witness to the boom in such activity.

There are surely more watercolourists setting up their easels in front of the classic views of the Grand Tour than at any time since the great age of watercolour drawing, when RWS exhibitions would contain vast numbers of foreign watercolours by artists like Prout, Callow, David Cox and J. F. Lewis. As we have noted, a prime reason for the popularity of such works – and particularly those of Venetian subject matter – was the role they could play as souvenirs. They were mementoes for a less wealthy audience than the aristocratic patrons of Canaletto's grand Venetian *vedute* of the eighteenth century.

While professionally produced photographs, amateur snapshots and postcards have long served as reminders of admired places, it remains to be seen whether the availability of professional-standard cameras to every traveller, and the creative possibilities these offer, will threaten the livelihood of contemporary view painters. I hope that the watercolours reproduced in these pages will show that there is no substitute for the painter's view of Venice.

Nevertheless, photographs of some of the subjects that have been depicted are also illustrated here. These are included because on occasions it will

Lorna Binns painting Palazzo Dario, November 1989

be of interest to make comparisons with the artists' work and to understand the value of their insight. Such comparisons are not gratuitous, for it cannot be denied that painted representations of the city are no longer our principal everyday sources of reference. The modern audience for paintings of such a well-documented icon as Venice are being made increasingly aware of the camera's version of the city. It is the choice of the artists whether they wish to take account of this fact or not.

Sometimes these photographs are approximations only of the subjects as seen by the artists, and were usually made on a different occasion. Even when a shot was taken looking over the artist's shoulder, it should be remembered that, with its dazzling array of lenses, filters and other technical facilities, the camera can manipulate and distort the truth more than any painter would wish to do.

Also reproduced throughout the book are preparatory studies in line and paint, which in some cases have led to the formation of the artists' principal watercolours. A number of painters tend to work

Diana Armfield
STUDY IN CAFFE QUADRI
*The artist has sketchbooks full
of evocative pencil studies of
figures – people walking,
people waiting, people sitting,
people talking – in Venice*

to their audience as they are today. Prout could get away with a window too few, as long as the reasonably knowledgeable viewer could recognise buildings and there was sufficient sense of place. This would not do for today's topographically-minded artists. Nonetheless, like their predecessors, they work from the information absorbed into their trained visual memories, with the aid of more factual records.

But everyone's approach to painting is individual and sometimes idiosyncratic, as the illuminating accounts written by the commissioned artists demonstrate. The less topographically-inclined painters, like Hans Schwarz, will simply sit down and get on with it. However, as Lorna Binns recalls, such fortitude can have its unforeseen drawbacks:

> The funniest time I had was when, painting in what I thought would be a hidden, undisturbed spot, disaster struck. A sudden wind lifted up my packet of spare watercolour paper and skimmed it into the canal. It must have reached the Lido by now. Then one after the other my three sponges hopped into the canal.
>
> Then came a hullabaloo behind me – a great crowd of Italians demonstrating, with a long banner, much too wide to turn the corners and causing them untold difficulties. They were blowing whistles, trumpets and shouting through a megaphone. I never knew what they were objecting to, but one and all gathered round me, saying '*bella*! *bella*!'.
>
> When I turned away from them to my view, a large boat had silently moored right in front of me, totally hiding the reflections in my painted view. The heavens opened suddenly and I fled for shelter to a bar and a much-needed cappuccino. That was the last day and, alas, the last painting.

straight onto the final sheet, directly before the subject, and will have no preparatory material. Others might employ a combination of methods of information gathering. It will indeed be noted that several of the artists remark that they use photographs for this purpose.

It is worth emphasising that photographs make excellent reference guides to, for instance, the number of windows on a palazzo façade. Before the coming of age of the camera, such a concern was perhaps of less importance to artists – excepting the meticulous Ruskin and his followers – as accurate photographic records of such features were not so readily available

Lorna manages to make light of what sounds like a protracted and frustrating series of events, which took place at the end of a stay in Venice early in November 1989. This occasion proved a rewarding opportunity to spend some time in the city with a group of Royal Watercolour Society Members – a number of them artists involved with this book – and their guests.

That most of the experienced visitors apparently adjusted within a few hours to the extraordinary change in visual phenomena and got straight down to work was remarkable. Those new to Venice reacted in differing ways to the abundance of new visual data that surrounded them wherever they went. Harry Eccleston recalls his first reactions in lines which seem to echo the verses from Byron's 'Beppo', quoted earlier:

> I shall never forget the moment, when having
> crossed the Lagoon in the dark from the airport
> and entered the city by a relatively unlit canal, we
> suddenly turned into the Grand Canal, a glitter-
> ing, bustling highway, with boat after boat, and
> magical palace after magical palace. This I
> thought, when we unloaded at the Rialto, could
> not be repeated. Yet it was to an astonishing
> degree, for every square foot offers a visual
> excitement I have never found in any other city.
> Cross a square, or look down a canal from a
> bridge, with or without a singing gondolier, and
> there is always a visual surprise; architecture
> which ranges from the beautifully austere to an
> exuberance I had never envisaged.

Faced with such phenomena – their initial wonder and excitement over – one or two artists seemed to freeze before the enormity of the experience. Truman Capote said that 'Venice is like eating an entire box of chocolate liqueurs at one go'. No wonder that painters might find the city indigestible on their first encounter. Nevertheless, the pages that follow will show that each commissioned artist managed to find in that box some aspect of the city which they could make their own.

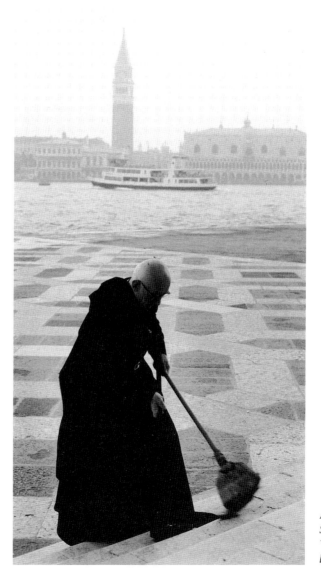

A monk sweeping the steps of San Giorgio Maggiore: Venetian life is not quite like life anywhere else

25

Opposite
Map of Venice,
showing locations of some of
the subjects reproduced
in this book

Venice, however, is much more than a visual feast, or indeed a stage set. It is a real, extraordinary, lived-in city. It is a civilising environment on a human scale that is expressive of a culture that humanity can be proud of. It has clearly inspired affection and respect in the artists who have exemplified these qualities in their work. There is nothing to equal the magical and sometimes private experiences that these few square miles of water, brick and stone can yield to those who are open to them. Perhaps the last word should belong to Wilfred Fairclough, one of the true wizards of Venice:

The time to go up the Campanile is at night, with a full moon and a clear sky. It is absolutely out of this world. It looks as if the sky has been turned upside down. It is quite magical and with the Italian full moon there is a very good light, much better than the British full moon. You can see everything below you and the boats going round in the Lagoon are tracing little shafts of light. It's quite remarkable. I was put on to it by the landlady of the hotel where I was staying and she insisted that I went up – absolutely marvellous.

Wilfred Fairclough
Towards the Salute from the Campanile

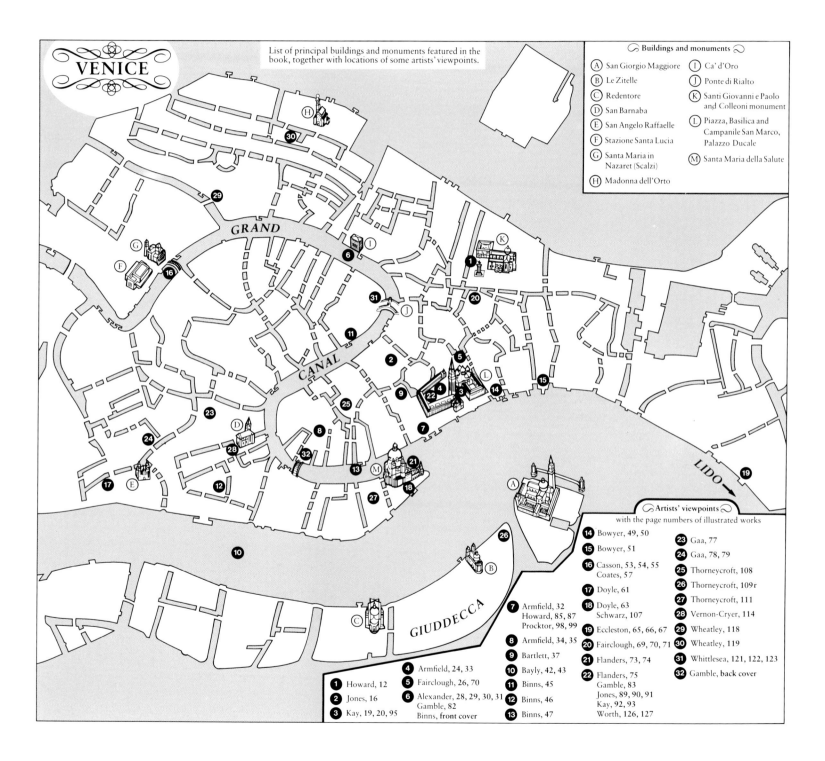

VENICE

List of principal buildings and monuments featured in the book, together with locations of some artists' viewpoints.

ᘓ Buildings and monuments ᘓ

- (A) San Giorgio Maggiore
- (B) Le Zitelle
- (C) Redentore
- (D) San Barnaba
- (E) San Angelo Raffaelle
- (F) Stazione Santa Lucia
- (G) Santa Maria in Nazaret (Scalzi)
- (H) Madonna dell'Orto
- (I) Ca' d'Oro
- (J) Ponte di Rialto
- (K) Santi Giovanni e Paolo and Colleoni monument
- (L) Piazza, Basilica and Campanile San Marco, Palazzo Ducale
- (M) Santa Maria della Salute

GRAND

CANAL

LIDO

GIUDDECCA

ᘓ Artists' viewpoints ᘓ
with the page numbers of illustrated works

1. Howard, 12
2. Jones, 16
3. Kay, 19, 20, 95
4. Armfield, 24, 33
5. Fairclough, 26, 70
6. Alexander, 28, 29, 30, 31
 Gamble, 82
 Binns, front cover
7. Armfield, 32
 Howard, 85, 87
 Procktor, 98, 99
8. Armfield, 34, 35
9. Bartlett, 37
10. Bayly, 42, 43
11. Binns, 45
12. Binns, 46
13. Binns, 47
14. Bowyer, 49, 50
15. Bowyer, 51
16. Casson, 53, 54, 55
 Coates, 57
17. Doyle, 61
18. Doyle, 63
 Schwarz, 107
19. Eccleston, 65, 66, 67
20. Fairclough, 69, 70, 71
21. Flanders, 73, 74
22. Flanders, 75
 Gamble, 83
 Jones, 89, 90, 91
 Kay, 92, 93
 Worth, 126, 127
23. Gaa, 77
24. Gaa, 78, 79
25. Thorneycroft, 108
26. Thorneycroft, 109r
27. Thorneycroft, 111
28. Vernon-Cryer, 114
29. Wheatley, 118
30. Wheatley, 119
31. Whittlesea, 121, 122, 123
32. Gamble, back cover

27

GREGORY ALEXANDER

Overlooking the Grand Canal to the north-west of the Ponte di Rialto, the Ca' d'Oro is perhaps the most revered of the private palazzi of Venice and is an icon of the high Gothic architecture of the city. It was built for the Procurator Marino Contarini by Matteo Raverti, a sculptor, between 1425 and 1440. That it is a sculptor's building can still be seen today in the gloriously elaborate carving of the once gilded façade, which remains a deeply satisfying ensemble. In the 1840s the Ca' d'Oro was occupied by the ballerina Marie Taglione who proceeded to carry out extensive and destructive renovation works, which fortunately largely spared the canal frontage.

John Ruskin, who deplored the ballerina's philistinism, made at least one notably beautiful watercolour drawing of the façade of the Ca' d'Oro, perhaps fearful of its eventual destruction. 'Of what remains,' he wrote 'the most beautiful portions are...the capitals of the windows in the upper story, most glorious sculpture of the fourteenth century' (presumably an English misreading of the Italian *quattrocento* – fifteenth century). For Henry James it was '...the most romantic façade in Europe'.

Gregory Alexander has chosen to emphasise the romantic associations of the façade by setting it in the context of the *Regatta Storica* – the historical regatta – held on the Grand Canal on the first Sunday in September. This large and ceremonial watercolour glows like the golden mosaics of the Basilica San Marco and reflects the Byzantine heritage of Venice. Gregory has set the precious façade within a formal and symmetrical composition which serves to emphasise the icon-like formality of the image. Before the

gracious façade an equally elegant array of boats energetically thrusts through the striped waters of the canal.

This is clearly not a topographical watercolour in spite of the clear reading of the palazzo's architectural detail – gilded as the artist perhaps imagined it might have been in the period to which the gondoliers' costumes also appear to allude. Neither is this a transcription of a scene the artist has witnessed, for, like Jacqueline Rizvi, Gregory has taken a theme of Venice personified in an age of glory. Indeed, as the artist explains, it was not necessary to have seen the particular incident. The picture came about as a result of a combination of experiences and ideas:

Dare I confess that I have never actually witnessed the regatta in Venice – I had hoped never to be found out – but one must come clean. This painting, and others that I have produced on the same theme, came about because of a chance moment when I was in Venice one February. Whilst crossing a bridge I was greeted by the image of six or seven decorative boats, with men dressed in medieval costume rowing frantically for all they were worth – I was spellbound – somehow the costumes and boats were just right – I was immediately transferred back to Canaletto's time.

Some six months later, back in my studio and surrounded by the studies and paintings I had made in Venice, I came across the drawings I made that day – again I was struck by the 'rightness' of the figures and boats and set about con-

structing a painting.

I wanted the whole painting to be very decorative and filled with pattern – almost over-the-top, like Venice itself. I needed a highly decorative backdrop and so naturally chose the Ca' d'Oro, of which I had already made a study. I decided to underline the painting with a border that had a kind of medieval Italian flavour, and then fill the picture with boats and people and movement.

I drew the painting out very carefully and accurately, keeping it very flat and linear – sometimes drawing areas on separate sheets of paper and then tracing them on to the watercolour paper so as not to spoil the surface. When I was happy with the completed line drawing I wetted the paper thoroughly and splashed generous golden and pink washes all over the surface, letting them dribble and bleed into one another – almost as a counterpoint to the tight, linear drawing underneath. As this dried I slowly restated certain parts of the painting, so as to give some focus – finishing with opaque washes in the stylised water area and a few selective washes in the patterns on the buildings and border.

Thus the painting becomes a formal, even symbolic representation of the Republic of Venice, the Serenissima. It is interesting to examine some of the studies that have gone into the making of this image. These range from the structured drawings of the boats and oarsmen, which reveal a splendid breadth of draughtsmanship and control of perspective, to the ravishing watercolour sketch of the Ca' d'Oro, which displays the artist's painterly skills to good effect. These are among the disparate sources of information that he has utilised to serve the image of the regatta

which had clearly been in his mind since his February visit.

Gregory concludes, 'I hope, one day, to actually witness the regatta in Venice, if only to see if it is anything like my paintings!' He should be pleased when he does. With the recently revived carnival, the *Regatta Storica* is one of the principal festivals of Venice. It is an echo of the great regattas of the past that we see, for example, in the paintings of Canaletto. Horatio Brown's account of a Venetian regatta in his *Life on the Lagoons,* published in 1884, also gives a flavour of such a spectacle:

Then all the boats turn round and follow the race, the men rowing with all their might, shouting, gibing, screaming to each other – a mass of floating criticism, crossing and recrossing like black shuttles on the grey web of the water, yet with consummate skill avoiding the slightest touch upon any neighbouring boat. And looking back, the race and its following is like a comet with a long black tail, taking the curve of the canal by the Redentore.

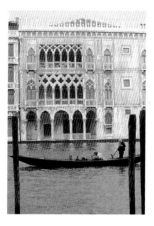

Ca' d'Oro from the Fondamenta Riva dell'Olio

Gregory Alexander
STUDY FOR REGATTA – VENICE
This large preliminary study exemplifies the artist's superb grasp of perspective in making a detailed compositional arrangement of one of the boats

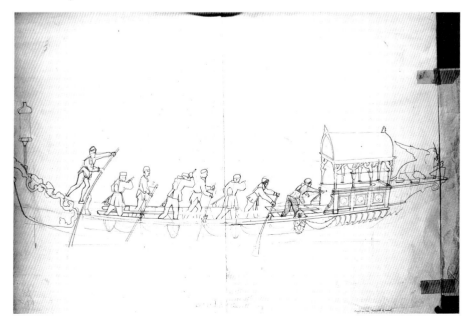

Gregory Alexander
CA' D'ORO

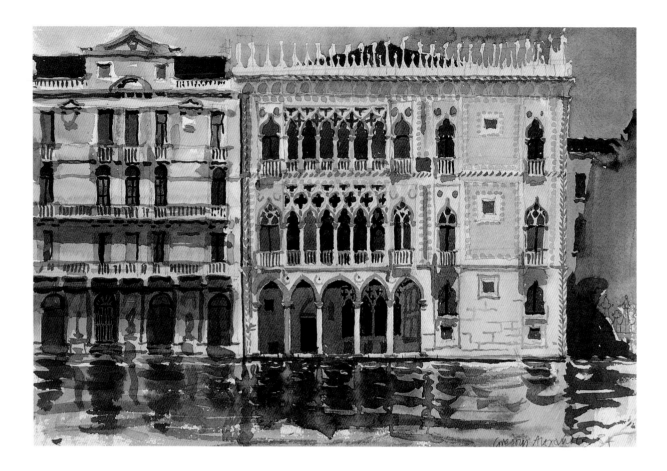

A quite frequent sight in modern Venice is that of men training for the *Regatta Storica*, as described by the artist. Come the appointed day in September and the palazzi of the Grand Canal are bedecked with heraldic banners, slung from the windows of their great rooms, out of which crane the necks of privileged Venetians and tourists. The unusual, but well-integrated stripes of the canal in this painting perfectly echo the pageantry of the occasion and the pattern of many of the banners themselves. Gregory's picture manages to enshrine the ceremonial and mythical character of this most Venetian of events.

Gregory Alexander was born in 1960 at Ramsgate in Kent. He studied in Canterbury and at the West Surrey College of Art and Design. He has travelled widely and his work reflects his interest in the human figure as well as the art of Africa and Asia. He has had several one-man exhibitions in London and the South of England. Gregory, who still lives in Kent, was elected an Associate of the Royal Watercolour Society in 1984 and in 1987 was made a full Member.

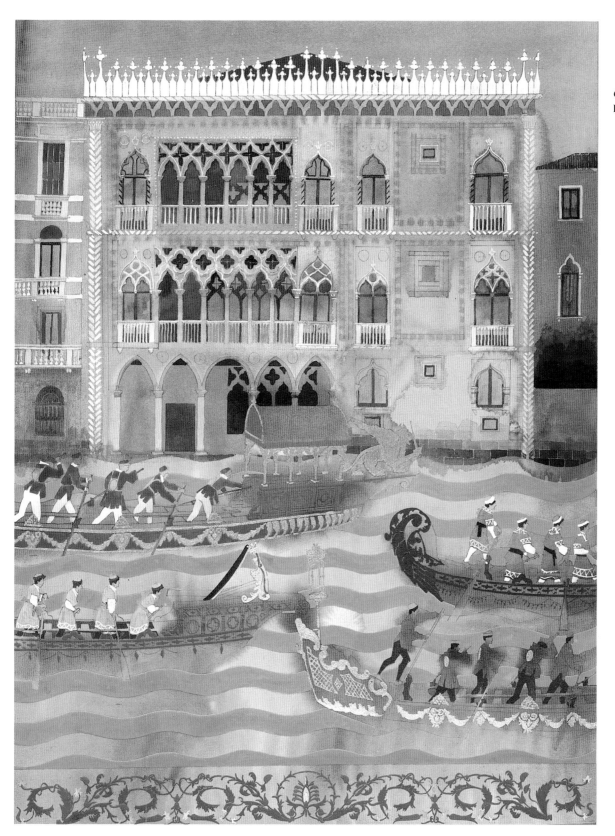

DIANA ARMFIELD

A frequent traveller to Venice, Diana Armfield has developed a considerable body of work set there. She is a painter of places and her Venetian work conveys perhaps an even stronger sense of the life of the city than of its architectural detail. Her sketchbooks abound with delightfully drawn and atmospheric pencil studies of scenes in the city. Very often in these studies, groups of Venetians and tourists, dogs, cats and pigeons feature prominently. So many view painters and topographical artists use figures as formal props to aid their compositions, that when we come across an artist who successfully integrates figures and animals into their environment, it is sometimes hard at first for us to recognise the difference.

Diana Armfield's interest in the human Venice is evident in the delightful study in watercolour and pastel of the interior of Caffe Quadri. Popular in the nineteenth century as the meeting place of the occupying Austrians, this famous café is situated directly opposite the even older Caffe Florian, on the north side of the Piazza San Marco. From outside, it is today the

café with the loudest musicians, but inside the comparative peace and rich decorations are suggested in this intimate study of a group conversing.

Just as Turner would introduce human and animal life into his townscape watercolours and his interior drawings, Diana aims to portray the totality of the Venetian scene. It is very much a city on a human scale and one in which one is continually aware of man's precedence over machine – a rare enough experience and one the artist clearly believes worth recording.

Diana's principal work depicts the busy Campo San Stefano, one of the finest squares in Venice. Clearly it has long been so judged, for in his travel book, *Coryat's Crudities. Hastily gobled up in five moneths travels*, published in 1611, Thomas Coryat wrote of 'the Piazza of Saint Stephen which is the most spacious and goodly place of the Citie except St Markes...'. Diana's delightful watercolour of the campo features the three westernmost bays of the Church of San Stefano, which was built in the third quarter of the fourteenth century and enlarged in the fifteenth. Before the church is a statue of Nicolo Tommaseo, the nineteenth-century patriot, sculpted by Franco Bazzaghi in 1882. These immovable elements and the neighbouring houses form the stage set for the artist's appreciation of the busy life of one of Venice's principal squares:

> San Stefano is one of those large generously proportioned campos in Venice where there is always some life going on. You pass through it on your way over to the Accademia from San

Diana Armfield
<small>FIGURES BY THE GRAND CANAL</small>
This characteristic sketchbook study illustrates the artist's interest in compositions of figures in particular settings. Here the backdrop is the Salute

Marco. One corner leads to the Music
Conservatoire, another to a row of little family-
run shops.

The statue in the centre makes a natural gath-
ering place for students, mothers and grand-
mothers with their children. Standing in groups
of three or four, a little away, are men in over-
coats engaged in conducting long discussions,
probably about money. Their vehemence pre-
vents them from standing at all still; they beat
their own chests, poke a finger at another's, wind
imaginary string or chop the air. They turn away,
only to swing round, breaking up the original
grouping. I wish they would keep still! Behind
the statue there may be a game of football going
on and the place I should like to install myself is
sure to be where the lads have put their imaginary
goal. Little children try out their tricycles at full
speed.

We were there in February. I must have sat
drawing in that campo at least a dozen times on
previous visits without succeeding in developing
work from the drawings on our return. This
doesn't mean that the hours spent were unre-
warding. This time we had picnicked for lunch in
soft sunshine on the Zattere, warm enough
without a coat on there, and again it was shel-
tered from the sharp wind in Campo San Stefano.
I sat on a camp stool, braving the ball and the
tricycles, and drew in a small black sketchbook
the intended composition, which I more or less
kept to. The particular pleasure of it is the rather
plain pinkish wall of the church contrasted with
the busy darker left-hand side leading to the
shopping *calle*.

On other pages I made notes of groups or
single figures as they presented themselves. I

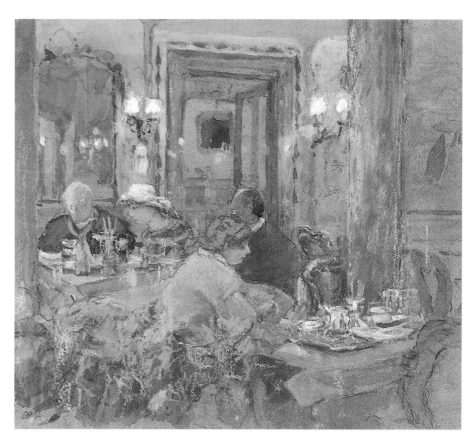

Diana Armfield
Look in at Quadri's, Venice

can't always use these drawn notes of people
directly, but I hope they enlarge my vocabulary of
possible sorts of people. I try to draw the ubiqui-
tous Venetian dogs, some of them seem to come
straight from Carpaccio paintings – a rather
brutal breed, but there are also pretty ones petted
along with the little dressed up children.

It is an animated scene and a constant source
of pleasure to sit there drawing. I think that over
the years certain squares, and particularly for me
San Stefano, become favourite arenas. If I am
undecided about where to settle for a painting, I
can always spend the time in one or other of these
places drawing.

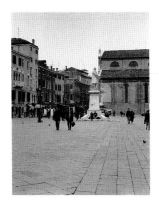

Campo San Stefano

The constant accumulation of material, the persistent jotting down of figure groupings and unusual vistas are all part of the essential storing of information which will be useful when the artist returns to her studio to produce watercolours and oils resulting from her stay. In working in this way, building up funds of brief drawings and notes in a sequence of sketchbooks, Diana is following in a great line of artists from Turner to Sickert – the painters of place rather than of topography, which requires more precise information.

It is not really necessary to judge whether everything is accurately described in the watercolour illustrated here, partly because architectural accuracy is not being sought of the work, but principally because the artist's fine descriptive drawing generalises the architectural elements to tell us as much about them as we need to know. It is indeed the general scene that matters.

The subtle colour washes are laid on with discretion, giving depth and balance, and the leaving of large areas of white paper helps to lend unity to the picture. More than anything, however, the artist appears to have concentrated on the splendid groupings of figures. It is in respect to these that the watercolour most varies from the sketch and here the artist has had resource to her copious figure studies. The result is a perfectly constructed view of the campo as those who know it will remember it – bustling and alive.

Diana Armfield was born in 1920. She has had many one-woman exhibitions at Browse and Darby and around Britain and her landscapes, figure scenes and still-lifes in watercolour, pastels and oils are included in the collections of institutions such as the Victoria and Albert Museum and the Yale Center for British Art. She has contributed to several publications and is on the advisory board of Leisure Painter *magazine. Diana was elected an Associate of the Royal Watercolour Society in 1977 and a Member in 1983. In 1989 she became an Associate of the Royal Academy of Art.*

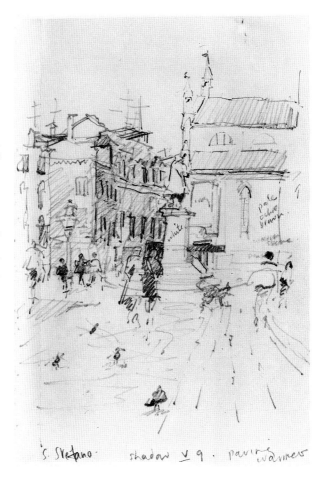

Right
Diana Armfield
Study for Campo San
Stefano, Venice

Far right
Diana Armfield
Campo San Stefano, Venice

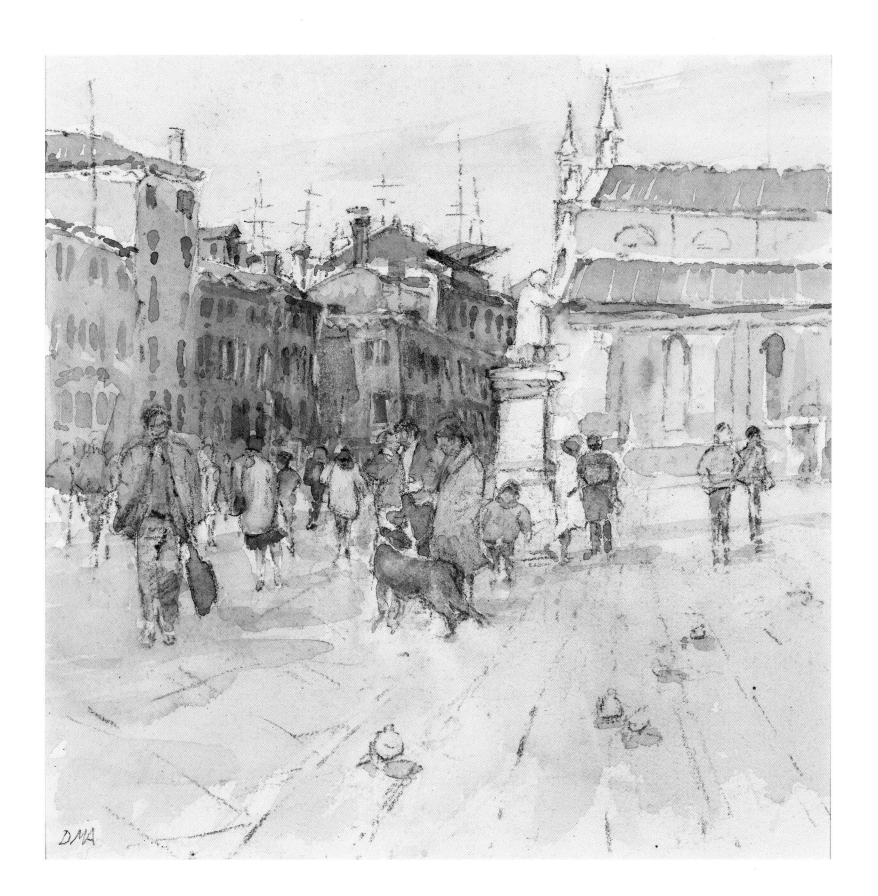

CHARLES BARTLETT

Charles Bartlett's preferred landscape is the marshlands of the Essex coastal regions, where he now lives. Through the flat, reed-covered wetlands of the area he sails his boat *Marguerite*, which is the apple of his eye. The luminous light from the open skies, reflecting off the network of rivers and rivulets forms his most characteristic subject matter. When he strays out of this loved countryside we find the artist seeking the equivalent characteristic of, say, a Welsh foreshore or a wide estuary. In all these places, Charles searches for an economical statement to convey the essential truth and beauty of the subject. The composition is usually simplified, even abstracted, and light and reflections in water typically become the principal interest in the scene.

No longer, however, does Charles Bartlett seem to convey the principal elements of his chosen view purely in abstract terms. There is nearly always a sense of place. Even if it is not reinforced by recognisable local landmarks, the true topography of the place is deeply considered and made integral to the painting.

It was clearly going to be of great interest to

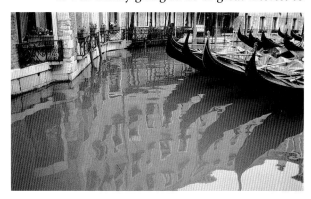

Bacino Orseolo

see how this lover of boats and water, this painter of luminous reflections, whose chosen subjects are invariably simple, open views, would react to the complexities of the Venetian waterscape:

This was my first visit to Venice and I was bewildered by the richness and complexity of the architecture and the canals. It was such a contrast to the rather austere landscape of East Anglia which is my usual subject matter. However, water and reflections have always played an important part in my paintings and so I decided to concentrate my studies in Venice in that direction. The light was another factor that impressed me; it was so soft and pearly, and amongst the islands and from the Lagoon everything appeared to be floating, the sky and water became one.

Reflections and Gondolas was painted in the studio from drawings. I usually paint from drawings and studies, mostly carried out in pencil or wash. Sometimes I include brief written notes, but having worked like this for many years I have cultivated a visual memory, particularly for colour.

Starting with my drawing I developed my composition in fairly abstract terms to produce a tonal and linear structure that would sustain the figurative elements. But the real subject of the painting is the shimmering reflections and luminous light.

The view depicted here was taken in the Bacino Orseolo, close to the Piazza San Marco, which

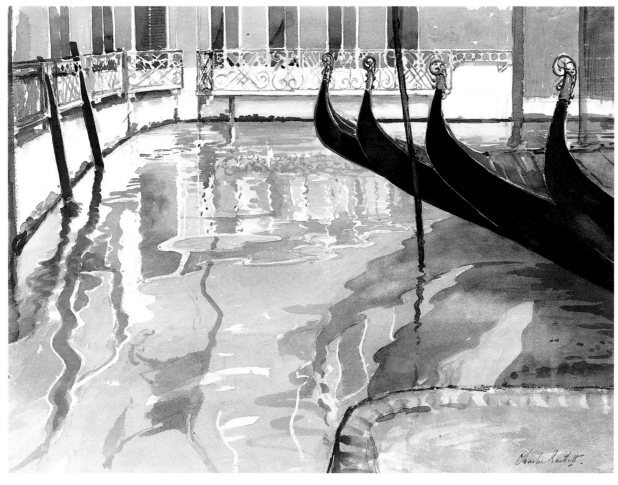

contains one of the city's principal gondola 'ranks'. While in Venice in November 1989, Charles spent considerable time studying this classic lagoon boat. Over many centuries this beautiful craft has evolved to be light, with a shallow draft, to have little water resistance, superb manoeuvrability and, for its mass, an extraordinary load-bearing capacity. The gondola's hull is purposely lop-sided to take into account the weight and positioning of the gondolier and is still constructed from some 280 pieces of wood from seven different trees. In 'Beppo', Byron described the gondola of the early nineteenth century. This is the boat that is so familiar from the paintings of Turner, Prout and their contemporaries – and, of course, the earlier pictures of Canaletto and Guardi:

Didst ever see a Gondola? For fear
　You should not, I'll describe it you exactly:
'Tis a long cover'd boat that's common here,
　Carved at the prow, built lightly, but
　　compactly,
Row'd by two rowers, each call'd 'Gondolier',
　It glides along the water looking blackly.
Just like a coffin clapt in a canoe,
Where none can make out what you say or do.

　　Tied up in their basin in *Reflections and Gondolas*, the prows of Charles Bartlett's boats are much as Byron would have known them, although today's leisure gondolas – as opposed to the *traghetti* ferries – are usually rowed by a single gondolier and the 'coffin'

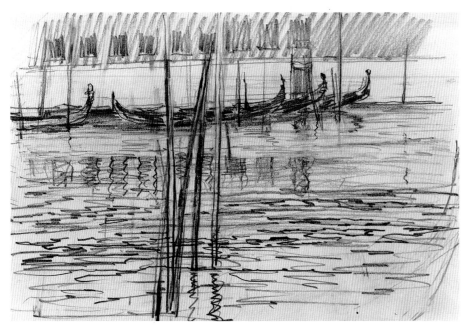

Charles Bartlett
STUDY FOR GONDOLAS IN
WINTER
*In this study the artist is to be
seen searching for an
abstracted arrangement of his
subject, which is finally
achieved in the watercolour*

The mirror-like surface of the canal reflected the warm glow from the buildings. This was contrasted with the dark shape of the gondolas and the mooring posts. The 'T' shaped composition is one that I have often used and in this case gave a powerful abstract quality to the watercolour. I visualised the painting in simple, strong shapes and did not want the effect of moving water. The long, horizontal shapes of the gondolas, with their brightly coloured covers, have been played off against the vertical shapes between the mooring posts. During day-time the water in the canals is rarely still due to water traffic, but early in the morning or late in the evening you do often get this mirror-like surface. The special light of Venice is I hope captured in this painting.

cabin has seemingly disappeared. This watercolour is, as we can see from the accompanying photograph and drawing, a fairly precise representation of the scene before the artist. It can, however, be seen that he has gently refined the composition to suit his needs. He has, for example, straightened the water-line at the top and eliminated most of the potentially confusing window reflections.

This sort of selectivity is one of the fundamental precepts of art and one which will always distinguish it from photography. Nonetheless, the photograph also makes clear the accuracy with which the painter was able to translate his on-the-spot drawing into a finished watercolour that is faithful to its subject and the bright misty light of the first days of November.

In another studio watercolour, *Gondolas in Winter*, however, it is evident that Charles has found an even clearer simplification of the Venetian scene:

This lyrical watercolour does, indeed, capture that November light. It also shows further refinement of the reflection, as if the water has been inspired by the long-exposure photographs of the nineteenth century, which turn the canals into a misty sheen. The drawing for this watercolour shows how the artist has taken the essential elements of the scene and transformed them into a symmetrical and extremely pleasing composition. Studying the thoughtful watercolours and etchings of this artist and their subtle stylistic development, it is not a surprise that his adaptation to the canals and gondolas would involve a period of intensive self-education; if anything, because the subject is so 'natural' for him.

This meditative study shows Charles' special vision coming to the fore and promises much for future visits. As he himself says, 'Venice is such a powerful visual subject that one's first visit is dominated by the subject matter. I would like to return at some later date to treat it in a more personal manner.'

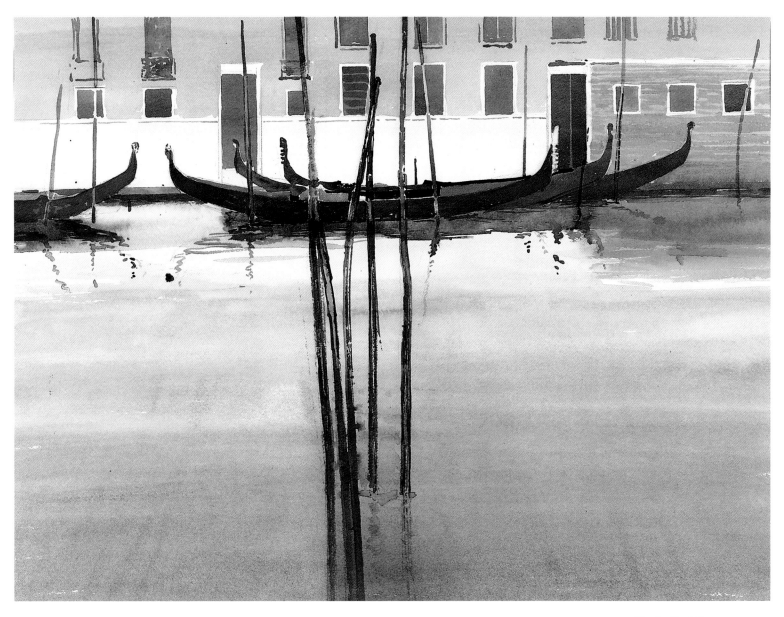

Charles Bartlett
GONDOLAS IN WINTER

Charles Bartlett was born in Lincolnshire and trained at Eastbourne and the Royal College of Art. A distinguished printmaker as well as a painter, he has taught at Harrow College of Art, but now concentrates on his own work, which is represented in most of Britain's important municipal galleries. He also has work in the collections of the Arts Council of Great Britain, the Victoria and Albert Museum and in the Albertina, Vienna. Charles lives near Colchester and was made an Associate of the Royal Watercolour Society in 1959 and a full Member in 1970. In 1987 he was elected the Society's President.

CLIFFORD BAYLY

The knowledge that Clifford Bayly's only Venetian visit was some years ago suggested that it would be interesting to find how he would portray his current vision of the city. Clifford is an artist whose extensive travels are recorded in paint, not so often as a factual description, but more likely as a telling and memorable image, an evocation of the spirit of the place. After a number of years, how had images of Venice been distilled and would his sketches and photographs provide the intelligence needed to realise these images? The artist explains how he tackled the commission:

My stay in Venice was a very short one and a long time ago. However, the vision has remained clear – you could say it has crystallised. When I look back over my studies and notes I am right back there again, as if I had only recently re-turned. The severe limitation on my opportunity to work while I was there was I feel a positive advantage, since I had seen the city with that first intense excitement and left before it faded in the face of the usual tourist troubles, which very soon beset the visitor and cloud the vision with their banality.

I decided that studies of the great, grand pano-ramas were definitely out for several reasons – Canaletto and Turner to name but two, not that one should quail under the responsibility to produce work that could possibly be seen along-side the masters, but because time did not permit and I felt a need to limit my studies to subjects of a more intimate nature.

Although I was naturally aware of the threat of the possible future inundation of Venice by rising water levels, I did not consciously let this influence my choice of subject. However, when I returned home and went through my studies, I realised that almost without exception I had picked images of things moving downwards and elements which graphically represented tidal levels and the action of sinking.

Thus an image of the city as beset by rising water, which later became elucidated in Clifford's mind, seems to have been sparked off unconsciously and was now found to be mirrored by the studies he had made on the visit.

Three Graces in a Gondola is a striking sub-ject. While its composition is similar to that of Tom Coates' painterly view of a gondola on the Grand Canal, there any comparison between the two works stops. Clifford Bayly's watercolour is a precisely worked-out image of graphic clarity. It, too, is su-perbly painted, but not as an effervescent celebration of paint for its own sake so much as with a fluid precision whose principal purpose is to illuminate the image the artist has chosen. The memory of this sight is evidently strong:

While crossing a small bridge on one of the lesser canals, I stopped and looked down over the parapet at the shadow of the bridge cast across the dusty surface of the water. While I was musing over these forms a gondola slid silently beneath me, downward into the shadow of the bridge, on into a pool of light from beneath the

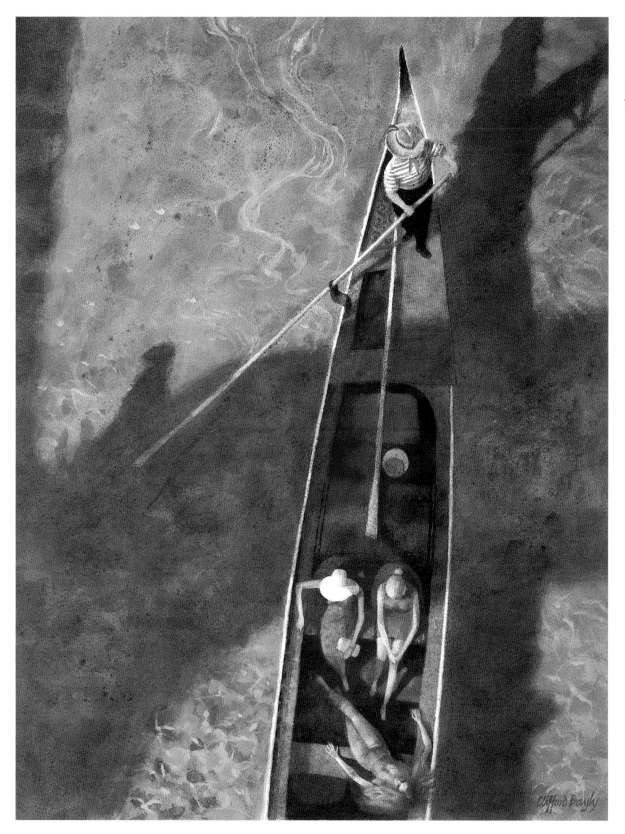

Clifford Bayly
THREE GRACES IN A GONDOLA

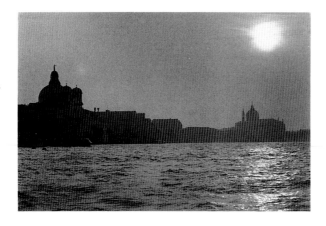

The Zitelle and the Redentore, from a vaporetto in the Giudecca Canal

So we advanced into this ghostly city... Other boats, of the same sombre hue, were lying moored, I thought, to painted pillars, near to dark mysterious doors that opened straight upon the water. Some of these were empty; in some, the rowers lay asleep; towards one, I saw some figures coming down a gloomy archway from the interior of a palace: gaily dressed, and attended by torch-bearers. It was but a glimpse I had of them; for a bridge, so low and close upon the boat that it seemed ready to fall down and crush us: one of the many bridges that perplexed the Dream: blotted them out, instantly.

arch and then disappeared with its three female passengers just as silently. Something in this purely visual experience touched a chord in my subconscious... Three females (a favourite theme of mine), 'Three Graces', shades of *Primavera* perhaps, sliding silently downward through my vision.

I had to record this in the form of a drawing with notes, but now I find it difficult to see this image objectively. A bucket became a moon glowing coldly in its own small night; the shadow of a figure crossing the bridge – something rather than someone.

It is a haunting image, one that might just send a slight thrill – or perhaps a shudder – through those who know the city.

In his *Pictures from Italy*, published in 1846, Charles Dickens described a comparably dreamlike experience from a gondola:

Clifford describes his rather different reasons for painting the watercolour of the once-capsized *Tide-Painted Ship*, tied up in the Giudecca Canal:

At first I was just interested in the unexpected relationship of a sea-going ship moored in front of typical Venetian architecture and also in the pale, silvery-blue light, which washes over the whole subject, binding these two physically unrelated elements together.

It seemed worth making a small study with colour notes, but it was only when I looked at this drawing later that I saw a further significance in the stratified tidal marks, which cover the side of the ship's hull. These lines appeared to me to be calibrating possible future water levels against the height of the buildings. Over-fanciful perhaps, but sufficiently promising as an idea for me to work with this concept as the subject.

In this superbly handled watercolour, taken across the afternoon sunlight, the artist's powers of recall are particularly evident. His pencil studies, built up with the help of photographs and quick notes made

Clifford Bayly
STUDY FOR TIDE-PAINTED SHIP
In this study the artist is assessing the relationship of shapes and volumes of the Redentore and its surrounding buildings

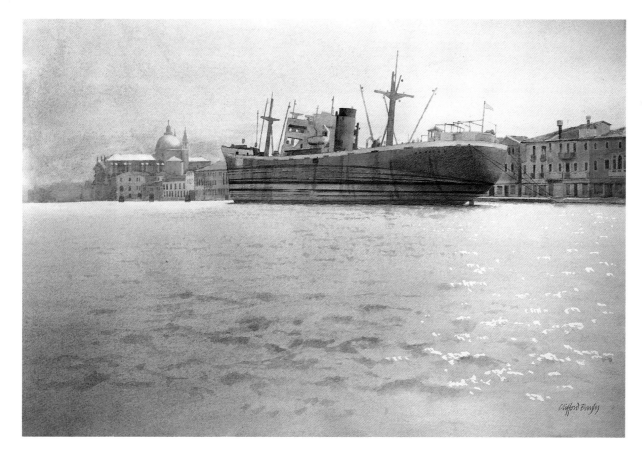

Clifford Bayly
TIDE-PAINTED SHIP

aboard a *vaporetto* as it criss-crossed the canal, provided the information he required. Comparing the drawing illustrated here with the finished work, we can see that having first recorded the architectural detail he has eventually allowed some of it to become subsumed in atmospheric effect for the better good of the final work. For example, the windows in the Church of the Redentore have disappeared, giving it its proper place in the decline of clarity as the Giudecca waterfront recedes into the mist. This use of aerial perspective lends an essential depth to the composition.

The Giudecca is a string of eight islands lying opposite the Zattere to the south of Venice and was the Jewish quarter of the city between the thirteenth and the sixteenth centuries. Behind the buildings on the waterfront are some large gardens, otherwise scarce in Venice. From the *vaporetto* the most familiar land-marks are the Zitelle and Redentore churches. Designed by Palladio and built between 1577 and 1592 to commemorate the end of a plague, the Redentore, or Church of the Redeemer, has ever since been the scene of a thanksgiving festival every July.

Born in London in 1927, Clifford Bayly studied at St Martin's and Camberwell Schools of Art. He taught at Maidstone College of Art for twenty years. In addition to his painting in various mediums, he has provided much illustrative work to commission, as well as producing his own instructional books. He has had one-man exhibitions in Britain and Australia, where he frequently travels, and has work in many corporate as well as private collections. Clifford lives in the Kentish Weald. He was elected ARWS in 1981, RWS in 1984 and Vice-President of the Society in 1987.

LORNA BINNS

Although not the youngest in the group of members of the Royal Watercolour Society visiting Venice in November 1989, it is true to say that Lorna Binns went about her painter's task with as much energy as any. Working straight onto the watercolour paper, with no under-drawing and, to the uninitiated observer, little apparent concern for compositional matters, she would start laying in her delicate washes in front of the subject.

On arrival, Lorna exclaimed that something marvellous seemed to happen to her blood each time she returned to the city. Nevertheless, she needed a settling in period, during which her sensibilities could adapt from the delicate colours of the British landscape to the abundance and richness of Venice. This acclimatisation became quite apparent as, with each day that passed, the watercolours became bolder and increasingly inspired. She is a painter who lives on her sensibilities and an almost telepathic communication of her brush with her subject. However much she might be in control of what results, Lorna declares herself unaware of how it is achieved. Here she indicates her approach to painting Venetian subjects:

I have to clear my mind of the many, many works of Venice I have seen and of the terrifying, intrusive thought that Venice paintings sell. I have learned to accept tourism and I neither see nor hear when it pleases me.

The Venetian palaces are to me so beautiful and the architecture so controlled, I look at them and picture the building of them in the 14th and 15th centuries, the control exercised and the skilled craftsmen, and imagine how they went about it and the tools they used. I should like to think that my work held something of the timeless quality and the fellow feeling of craftsmanship of the past. When I am looking for a subject, I see something very beautiful which excites me and in that moment the reason for working and the final feeling of the painting is born.

I paint directly onto the paper using a No. 10 brush and a very fine brush for drawing, and I disturb the paint, once applied, as little as possible. I like to use thin transparent washes, through which the white paper glows. I wet the paper first, leaving, if I want them, white areas dry. I sit on a low stool, my board flat on my knees and my materials on the ground beside me. I tilt the board in all directions as I work, if and when I want the paint to run. I bring up the background to a required outline rather than define the shape of something first.

I look long and hard at the subject before I begin, chiefly to eliminate a great deal. I study the structure so as to understand it, but not necessarily to portray it. As I begin to work my brush begins to flow fast and I am not sure what I do. My concentration is intense and suddenly comes to an end after perhaps two hours. I never know the length of time I take. I do not return to the painting but face it to the studio wall, look at it again after two weeks and complete it in the studio.

On the November visit I painted twice each

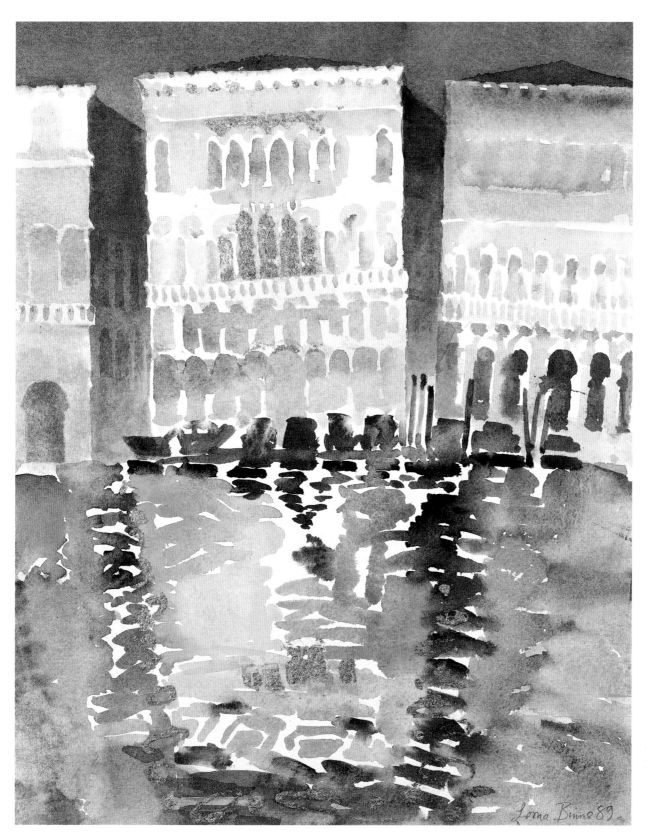

Lorna Binns
GILDED VENICE –
PALAZZO LOREDAN BY NIGHT

45

Lorna Binns
THE BLUE BOAT
*Tied up in the Rio delle
Eremite, a side canal off
the Zattere, this boat seems
to hover over the dancing
reflections that are so much a
part of Lorna Binns' Venice*

Right
*Palazzo Dario from
Santa Maria del Giglio
vaporetto stop.
This photograph shows that
this and many other Venetian
palazzi do indeed lean*

Opposite
Lorna Binns
PALAZZO DARIO

day and also tried some night painting. I should never tire of painting there, it could be for ever. Yet in the past I have been irritated by seeing so many Venice paintings and almost decided never to paint there again. But the RWS visit has totally changed my views and *Visions of Venice* will be fascinating in its variety of paintings and drawings from members.

Referring to the painting of the watercolour she has titled *Gilded Venice – Palazzo Loredan by Night*, Lorna writes:

Absorbed in painting, enclosed by the darkness, a full tide and golden rings endlessly dancing on the water, with the knowledge that Venice was once bright with gold, I had to apply gold leaf over the watercolour. As I worked, it was as though the glorious sound of grand opera was all around me.

Lorna Binns' vantage point was on the Riva del Vin on the opposite bank of the Grand Canal to the Palazzo Loredan. Built for the Zane family some time around the year 1300, the building gained its name from the Loredan family who occupied it in the early eighteenth century. Since then the palazzo has served

a variety of functions – from printing works, inn and hotel, to travel agency – and is presently in the charge of the Venetian authorities. This complex history has been reflected by alterations to the palazzo's architectural integrity and although its façade was closely analysed by Ruskin in *The Stones of Venice*, the building was described by Henry James in the late nineteenth century as a delightful creation, 'once a masterpiece'. Perhaps such niceties would hardly have concerned Lorna Binns as she sat in the November night, catching the dancing light bouncing off the canal – providing a clear analogy with theatre footlights. The artist makes another comparison:

I have always thought that the light in Venice flickers and dances and is thrown upwards. I find myself thinking of the dancing image on the ceiling from a cup of tea in sunlight.

The light is also thrown upwards from the water in a daytime view of the Palazzo Dario which

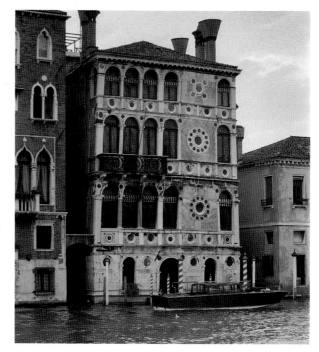

shows the palazzo floating in a shimmering swirl of brightly coloured reflections. It is an explosion of light and colour on the surface of the water, which anyone who knows Venice will recognise. Here, in the sharper light of day, the artist has represented the delightful Palazzo Dario faithfully. This diminutive, marble-encrusted building was built for Giovanni Dario in the last years of the fifteenth century and is a prime example of late *quattrocento* Venetian architecture. It was portrayed, famously, by Ruskin, who described it as an exquisite example of its type.

Lorna's Grand Canal of glistening Renaissance palazzi is as bewitchingly passed down to us in *The Memoirs* of a French ambassador to Venice of the late fifteenth century, Philippe de Commynes:

> It is the fairest and best-built street, I think, in the world, and goes quite through the city; the houses are very large and lofty, and built of stone; the old ones are all painted; those of about a hundred years standing are faced with white marble from Istria (which is about a hundred miles from Venice), and inlaid with porphyry and serpentine... In short, it is the most triumphant city that I have ever seen...

Lorna Binns was born near Sheffield in 1914 and after studying in that city went on to the Royal College of Art in the years immediately preceding World War II. After an early career in fashion she turned to painting and also worked on design projects with her late husband, the painter John Dawson Binns. Lorna has exhibited widely and her watercolours are to be found in many collections in Britain and overseas. She now lives in Surbiton, Surrey, and was elected an Associate of the RWS in 1973. She was promoted to full Membership in 1977.

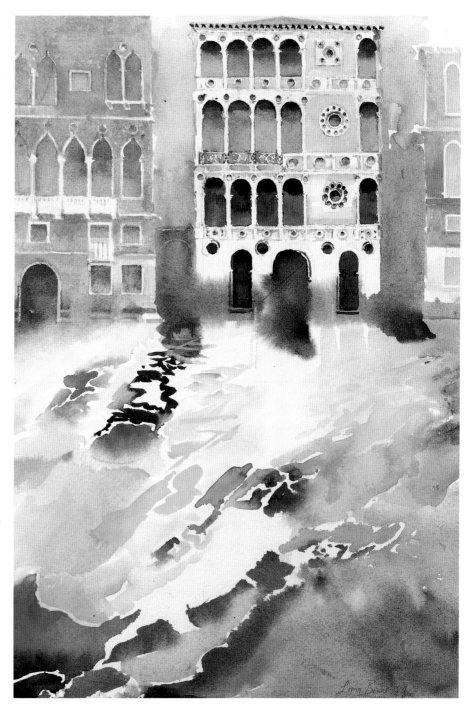

WILLIAM BOWYER

William Bowyer was making his first visit to Venice when he arrived a few days ahead of the Royal Watercolour Society group, in the last week of October:

> We approached Venice on a cold rainy evening. A woman sitting next to me on the boat had told me that her first impressions of Venice were the thrill of her lifetime. I must say the conditions in which we arrived were not the most perfect, but still the magical lights glittered through the rain-speckled windows of the boat, and gradually the sight of the church of Santa Maria della Salute, the Campanile of St Mark's Square and the Doge's Palace came into view. The following few days of exploration revealed that with so much to see we could have stayed for three months and still gone on finding treasures.
>
> The imaginative qualities of Carpaccio, the grandeur of Tintoretto, the amazing perspective tricks of Veronese and the marvellous Titian's Pieta will last in my mind for years.
>
> I was fascinated by the canals and if I had more time would have drawn from dawn till dusk. In the time available I settled for the waterfront by the Doge's Palace, which has been painted many times by so many painters throughout the years. The image of the church of Santa Maria della Salute against the light, the gondolas and St Mark's Square, the pink Doge's Palace with the glitter of the setting sun in the waters of the Lagoon, I found intriguing.

The principal subject that William Bowyer chose to paint in two closely related watercolours is one of the classic *vedute*, looking from the beginning of the Riva degli Schiavoni, across the entrance to the Rio di Palazzo and over the Molo to the Dogana and the entrance to the Grand Canal. Indeed, so plentiful with landmarks is this vista that it could equally accurately be described, for example, as being from beside the Ponte della Paglia, looking over the seaward end of the Piazzetta, with the twin pillars of the Lion of St Mark and San Teodoro, past the Libreria Sansoviniana to the distant Salute. In either case, it can be a daunting prospect for the view painter. As Henry James put it, '...the cockneyfied Piazzetta...introduces us directly to the great picture by which the Grand Canal works its first spell, and to which a thousand artists, not always with a talent apiece, have paid their tribute'.

It requires an artist of courage to take on such a view on his first arrival in the city. As a much-travelled artist used to presenting himself in front of such celebrated vistas, like the professional he is, Bill Bowyer got straight on with attempting to find a personal vision of the hallowed scene. The ease with which he seemed to settle down to painting directly in front of his subject seemed remarkable, and is shown in the fluent liquid brushwork of both watercolours.

However, it never is as easy as first impressions might suggest. We begin to get a hint of the struggle if we compare the viewpoints of the two works. The artist has started off on the edge of the Riva and, perhaps not entirely happy with the composition of the work, has moved inland a few yards in order to include the bridge, which leads the eye into the composition and adds greater perspectival depth to the picture. At the same time he has allocated the line of

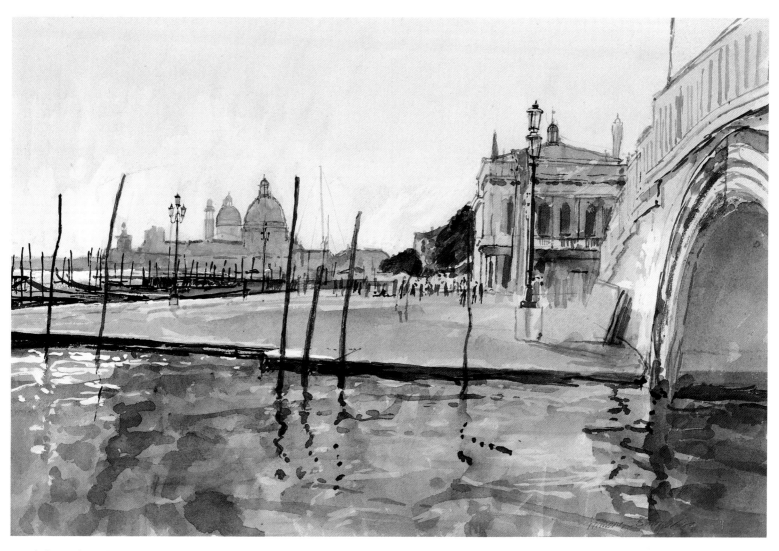

gondolas a less dominant role. If nothing else, this might tell us that there is no such thing as the perfect, classic composition, as some of the theories of the picturesque, on which early topographical artists were grounded, might have led one to believe. Before one of the most apparently composed and often-painted of the world's great views, even an artist of the stature of William Bowyer strives to apply his own personal way of seeing to the subject – whatever it may be – that is before him.

The Piazzetta was for centuries the formal entrance to Venice from the sea and the Molo was the state landing stage, the foundations of which were laid in 1342. In recent decades a principal gondola-rank, the Molo was, at an early stage of its history, the state granary. The Piazzetta has been described as a sort of

William Bowyer
THE MOLO AND
THE PONTE DELLA PAGLIA

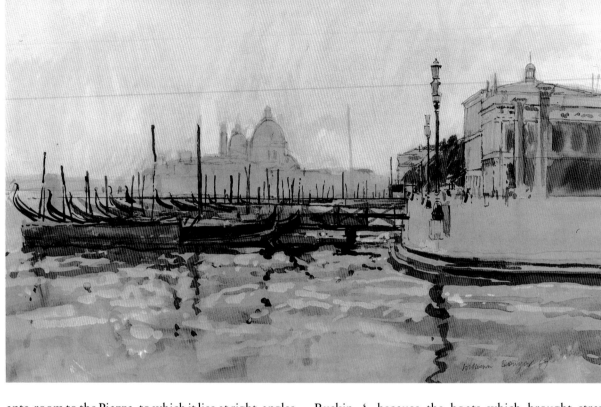

Right
William Bowyer
THE MOLO
This is the first version of the composition, in which the artist successfully tackles his subject, but the composition is to be further refined

Opposite
William Bowyer
RIO DEI GRECI

Below
Gondolas by the Molo

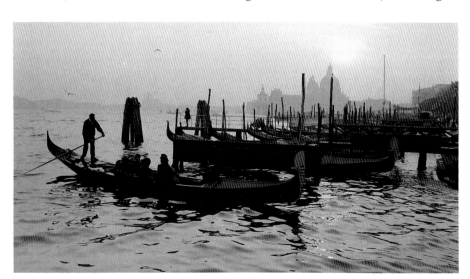

ante-room to the Piazza, to which it lies at right-angles, and was first paved as early as the mid-thirteenth century. The Rio di Palazzo, over which the artist was looking, runs beside the Palazzo Ducale and under the Bridge of Sighs, before emerging into the Lagoon. The Ponte della Paglia itself was so named, according to

Ruskin, '...because the boats which brought straw from the mainland used to sell it at this place', close as it was to the granary.

In the second volume of *The Stones of Venice*, Ruskin asked his reader to dream of having arrived in this legendary place by gondola from Mestre, rather than crossing the Lagoon on the railroad. This is the moment the gondola moves out of the Grand Canal past the Salute and heads for the Piazzetta:

> ...and when at last that boat darted forth upon the breadth of silver sea, across which the front of the Ducal palace, flushed with its sanguine veins, looks to the snowy dome of Our Lady of Salvation, it was no marvel that the mind should be so deeply entranced by the visionary charm of a scene so beautiful and so strange, as to forget the darker truths of its history and its being.

It is only a few minutes' stroll along the Riva to the next bridge, the Ponte Selpolcro, from which Bill painted in watercolour a view along the Rio dei Greci. In the distance is the leaning campanile of San Giorgio dei Greci. The church was built in the middle of the sixteenth century as the place of worship of the Greek community and the campanile was added before the end of the century. This is one of the several leaning towers of Venice, which, while providing appealing subjects for the painter, serve to remind one of the fragility of the city's substructure.

This view along the Rio dei Greci is another example of how the artist is able to take on a characteristic, if less legendary, Venetian prospect, and portray it in his own lucid style. It is as though he feels here no need for the standard pictorial aids of careful underdrawing, aerial perspective and atmospheric washes. He starts the work directly, drawing clearly with the brush, and confronts every element of the strong composition as it presents itself, ending up with a suitably clear, direct and well-structured painting. If there is a secret to all this beside the life-time of experience which lies behind it, it is perhaps that William Bowyer draws with paint, or to put it another way, he is a painterly draughtsman.

William Bowyer was born in 1926 and studied at Burslem School of Art and the Royal College of Art. His teaching career culminated in the position of Head of Fine Art at Maidstone College of Art. He now concentrates on painting. His subject matter in oils and watercolour reflects his extensive travels in Europe and Asia, although he is also well known for views of the Thames and for his portraits, some of cricketers. Bill, who now lives in West London, was elected a Royal Academician in 1981. He was made an Associate of the Royal Watercolour Society in 1959 and in 1974 was elected a full Member.

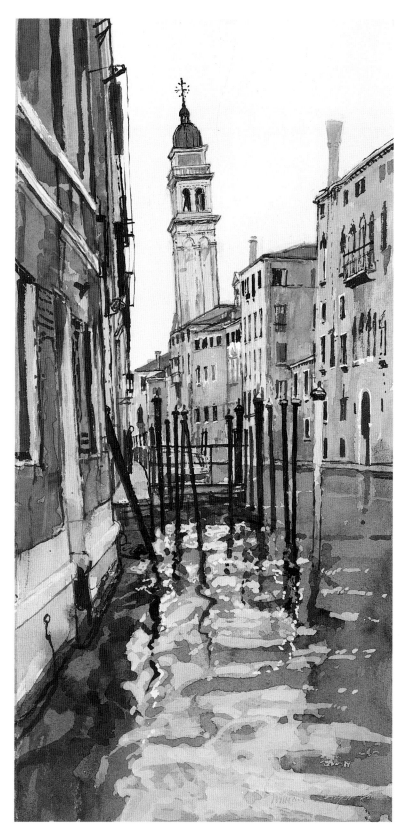

SIR HUGH CASSON

Despite the impression many guide books give, Venice is not a time capsule from any one period in history. It is an extremely fortunate survival of a medieval, Renaissance and Baroque city and therein lies the key: even Venice has changed with the years. If it remained a fifteenth-century city it would truly be a museum, and it would probably have done so only because of enormous decline. In other words, there would have been no great sixteenth-century Venetian painters and today's visitors would probably be visiting a relic even further ruined than the decaying and decadent city that Byron revelled in.

It has already been noted that a lack of prosperity, together with foreign occupation in the nineteenth century, may have contributed to the ultimate survival of earlier buildings, but even Venice is not totally immune to change and neither should it be. Sadly, Frank Lloyd Wright's design project for the Fondazione Masieri on the Grand Canal never received planning permission, and Le Corbusier's new hospital was never built. Only a few distinguished modern architects have been able to infiltrate Venice, principally with the somewhat peripheral and specialist Biennale pavilions in the Giardini Pubblici.

Such works, however, are the better side of the limited building programme in this century. Nineteenth-century building was mixed in quality, although some of it was very good, including the *fin de siècle* villas and hotels on the Lido, and much of it was essential. Venice would not have survived at all if it had not opened itself to the modern transportation systems of the outside world and built the railway bridge across the Lagoon to Marghera.

The bridge and station were constructed in the 1840s and soon became responsible for the shift of the entrance to Venice away from the traditional grandeur of the Piazzetta. This change was not always welcome to the more romantic of visitors. In *Death in Venice*, Thomas Mann had Gustave von Aschenbach thinking 'that to come to Venice by the station is like entering a palace by the back door'.

Nonetheless, the building of the railway station did open up the city to greater numbers of visitors. Its construction did, however, entail the destruction of a Palladio church and many other buildings. The original station has disappeared, to be replaced by a building that was finally completed in 1955, and next door the late seventeenth-century church of the Scalzi has recently been restored.

It is fitting that a distinguished architect and architectural historian should have chosen to represent for this project a vision of his first arrival in Venice, with the old railway station as his subject. It is, however, as a superbly economical and descriptive watercolourist and draughtsman that Sir Hugh Casson's contribution is included here. On his first visit to the city as a young man he already had the drawing bug:

Everyone remembers their first visit to Venice. I certainly remember mine...... Daybreak on a January morning in 1931. I had arrived by slow train from Istanbul – (2 nights on wooden seats) – an architectural student and a prisoner of my period. A rucksack, containing several sketchbooks but luckily no camera.

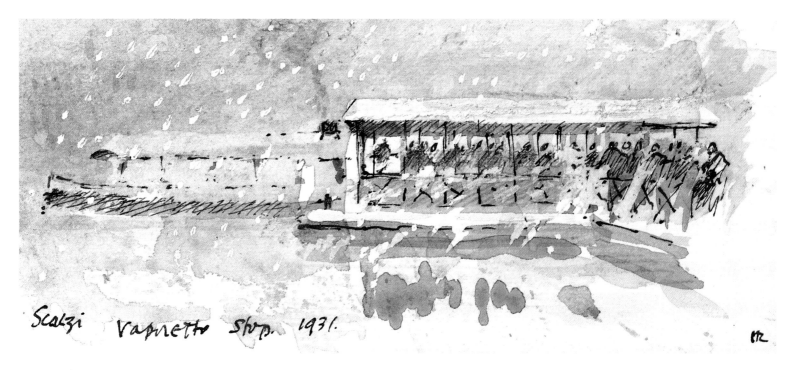

Scalzi Vaporetto Stop. 1931.

In those days memories had to be refreshed by postcards and your own scribbled notes and sketches: most of these have long since disappeared, but enough remain to recall what I saw as I came out of that old, arched and stuccoed station. 'Saw' is an understatement. It was like a sudden blow, as unexpected as the bitter wind carrying flurries of snow. It was still dark and very quiet. The quayside – too early for footprints – was blinding white – the canal coiled away to the left – like Ruskin's serpent – watchful and soundless except for the fierce flapping of wavelets against the snow-covered steps. Nothing else moved much – a few early workers, a barge steered by a man holding an umbrella against the snow... inky black smoke poured out from a moored *vaporetto*'s funnel.

Despite the cold it was difficult to leave the spot, even harder with frozen fingers to record it. In those days I drew with a fountain pen as I had been taught, smudging the shadows and tones with fingers and spit. I did not graduate to watercolour for nearly 30 years. Gradually the buildings opposite, grey, buff, apricot, hard tennis court pink began to glow faintly as the sun rose and the snow flakes gave up trying. The sky – up till now the colour of old iron rusting at the edges – paled to birds-egg blue. More workers arrived patterning the snow with their boots, shutters clattered open, a *vaporetto* discharged a load of Venetians bound for Mestre. The curtain had risen and I was lucky enough to have seen it rise.

Freya Stark used to say that Venice is the only city she knows of that greets you on every visit as if for the first time. All of us, I think, must agree

Sir Hugh Casson
Scalzi Vaporetto Stop
One of a series of studies, with which the artist explores the area around his chosen subject

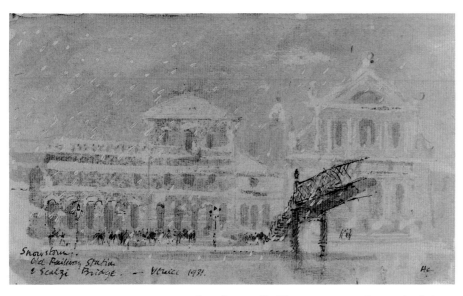

Sir Hugh Casson
SNOWSTORM – OLD RAILWAY
STATION AND SCALZI BRIDGE

PS The old railway station was replaced in the fifties. The iron bridge of the Scalzi – designed and built I believe in England – was replaced by the present stone bridge designed by Eugenio Miozzi in 1934. In the church of the Scalzi – the bare-footed friars – is buried Lodovico Manin – the 120th, the last of the doges who surrendered Venice to Napoleon and is buried in a simple tomb which merely says Ceneres Manini...
'The Ashes of Manin'.

to that, but sadly I have never again reached that illusion by arriving by train and walking out to be greeted by an embrace, with that magical combination of stone and water and light from which Venice has been wrought. Next time perhaps.

While those visitors lucky enough to arrive on the Orient Express share with back-packers that sweet emergence from the station, many of us now arrive by the newer portals to Venice, the road bridge and the airport. Nevertheless, the Fifties station remains the tangible and romantic link with the mainland and the far-flung homelands of those who come to pay homage.

Sir Hugh Casson's re-creation of the scene almost sixty years ago is most evocatively painted in his sparingly washed manner, with the wintry weather emphasised by leaving the bare paper and employing a good amount of white bodycolour. The accompanying sketches seem to be less for compositional purposes or information gathering, than a means for the artist to revive visually the completeness of this distant experience and feel his way around the subject once again. Once this process is achieved the finished picture is made, with exquisite results. We can gain the measure of the young artist's experience and feel the cold of what Osbert Sitwell described as Venice's 'unexpected winter beauty' in *Winters of Content*, published the year after Sir Hugh's first visit.

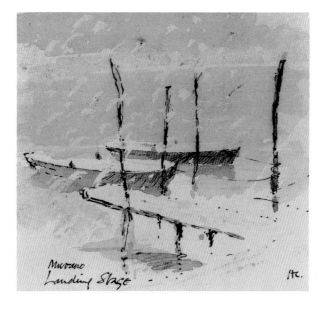

Sir Hugh Casson
MURANO LANDING STAGE
A study made on the island of Murano that captures the mood of a scene of wintered boats in the snow

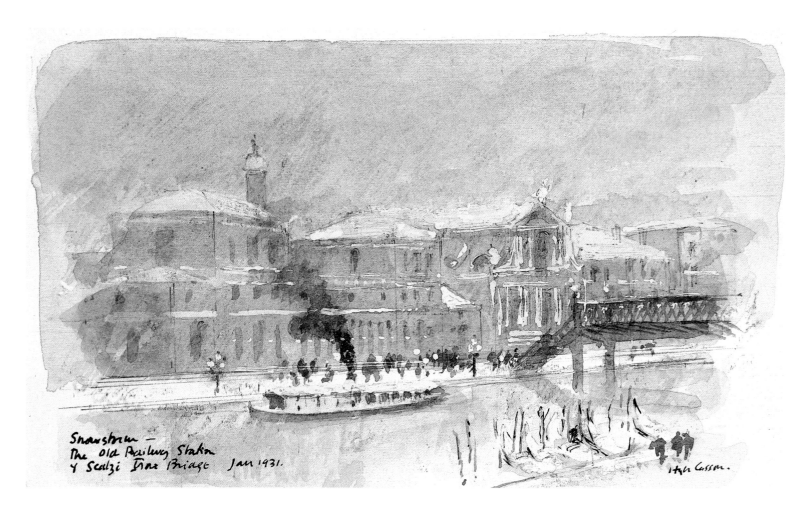

Snowstorm –
The Old Railway Station
& Scalzi Iron Bridge Jan 1931.

Hugh Casson.

Sir Hugh Casson was born in 1910 and was educated at St John's, Cambridge, and the British School in Athens. Since 1937 he has been in practice as an architect, designing a number of award-winning buildings and being elected to the Royal Academy, which he served as President from 1976 to 1984. He has been much involved in conservation, is a celebrated writer, *lecturer and broadcaster and has produced designs for stage sets and festivals. He is a prolific watercolourist and illustrated the Prince of Wales' The Old Man of Lochnagar. Sir Hugh lives in London. He was elected an Honorary Member of the RWS in 1970. In 1985 he became a Companion of Honour.*

Sir Hugh Casson
SNOWSTORM – THE OLD
RAILWAY STATION AND SCALZI
IRON BRIDGE, JAN 1931

TOM COATES

There can be little doubt that Tom Coates is one of the most versatile painters of his generation. His superb craftsmanship is turned to an astonishing variety of subject matter, usually with striking success. The speed with which he will lay in a life-size, full-length portrait in watercolour, while scarcely pausing from the banter that keeps both sitter and any audience amused, never fails to catch the breath. Tom is an unrepentant showman who loves to demonstrate his technical adroitness to an admiring audience.

Beneath the ebullient exterior, however, the serious painter is a fighter who has overcome very poor vision and who will not waste time on technical expertise alone. The skills are forever being pushed to their extremes, further to refine the artist's ability to express the world he gratefully perceives around him. Indeed the demonstrations at which he so enjoys performing are really shared celebrations of the miracle that man can paint his surroundings. That Tom does so with broad, exuberant brush strokes is characteristic of the painter we know. Sometimes, however, it is the more intimate and contemplative of his works that most touch one and seem to reveal most about the man.

Whether it is in oils, pastels or watercolour, Tom's best work nearly always seems to have something to reveal about the quality of the light. It is scarcely a surprise that Venice, the painter's city of light, should attract him:

One never tires of Venice – it always reminds me of Atlantis, risen from the depths of the sea.
On first arriving there by air, taking the water taxi, the smells, colour and excitement to the eye is overwhelming. The first thing I think of is how other artists have approached the subject and the splendour. You cannot help but be influenced by all the painters of the past and present.
I walked everywhere with all the equipment I could carry – I am sure my arms are getting longer with the weight of my burden. Reaction after reaction, everywhere I looked I would sense the others had been. I must record it my way – oh, get on with the work! So I sat and rotated on a 360 degree turn, painting and sketching all the splendours, finding my own subjects – protecting, I thought, some parts of Venice for myself. I found out much later that you cannot; it's always to be shared.
Working at the fish market on a busy day, trying to do a watercolour sitting on an old, broken fish box, I experienced the continuous build up of smells. Behind me was an old, drunken man throwing dead fish heads, building up the barrier between him and me. He won – I changed my position, joining the shoppers and merchants and putting in further distance from his strong throwing arm.

One can imagine the voracity with which Tom would have taken in the new experiences of Venice – if not the smells – and urgently noted them on paper. One such experience was of busy gondola traffic, seen against the light from the Ponte Scalzi, against the apparent silhouette of the railway station:

The river traffic is always exciting to paint. I

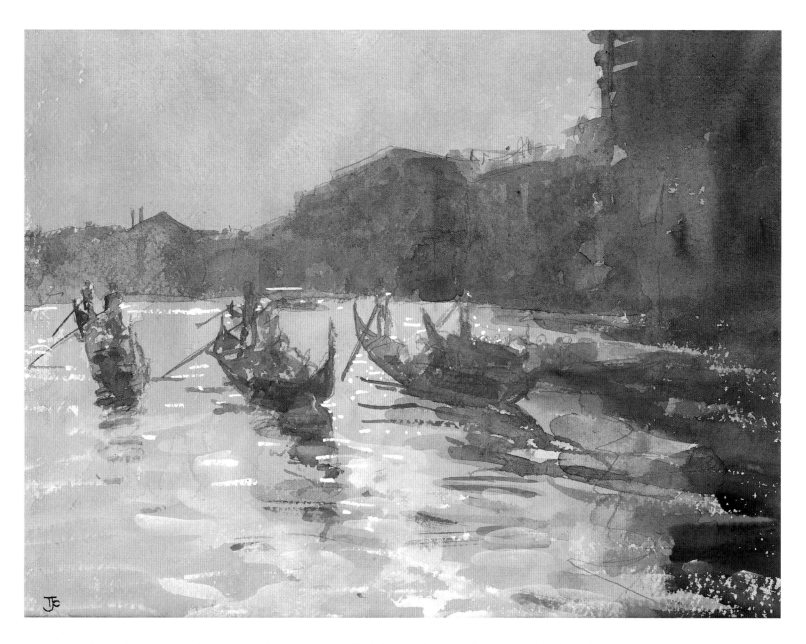

spent many hours listening to the music and arguments of the gondoliers. Italians are all opera singers. One evening, with light reflecting on the water, many groups of noisy gondolas packed the canal. Even the *vaporetti* had to give way. I had to sketch quickly in hurried strokes and washes of watercolour and bodycolour on some heavy, handmade rag paper.

Tom Coates
THE GRAND CANAL FROM THE PONTE SCALZI

57

The vigour with which the artist has worked this luminous watercolour is apparent in the reproduction. He has covered the grey paper with an all-over golden wash and then attacked it with broad strokes of blue watercolour and flecks of white bodycolour: some brief pencil outlines and the effect is captured – probably as the gondolas were slipping under the bridge. These evening parades of often serenading gondoliers will be familiar to Venice visitors. As long ago as 1783, William Beckford described in *Dreams, Waking Thoughts and Incidents* how such a serenade beneath a palazzo balcony,

> ...stilled every clamour and suspended all conversation in the galleries and porticos; till, rowing slowly away, it was heard no more. The gondoliers catching the air, imitated its cadences, and were answered by others at a distance, whose voices, echoed by the arch of the bridge, acquired a plaintive and interesting tone.

This folk language of the gondoliers seems to have all but vanished today, although it still flourished nearly eighty years after Beckford's visit, when Richard Wagner made one of his visits to Venice. He later described his experiences in the autobiography *My Life*:

> I heard for the first time the famous old folksong of the gondolieri. I thought the first call, piercing the stillness of the night like a harsh lament, emanated from the Rialto, barely a quarter hour's distance away, or thereabouts; from a similar distance this would be answered from another quarter in the same way...

When I was riding back late one evening along the dark canal, the moon came out and illuminated, together with the indescribable palaces, the tall silhouette of my gondolier towering above the stern of his gondola, while he slowly turned his mighty oar. Suddenly from his breast came a mournful sound not unlike the howl of an animal, swelling up from a deep, low note, and after a long-sustained 'Oh', it culminated in the simple musical phrase 'Venezia'. This was followed by some words I could not retain in my memory, being so greatly shaken by the emotion of the moment.

Right
A gondola going under a bridge. The full length of the craft is appreciated from above

Opposite
Tom Coates
A GONDOLA ON
THE GRAND CANAL

Another thrilling Venetian moment that we can still experience is the sight of a gondola slipping beneath a bridge, over which one leans in awe of the boat's unexpected length – only fully appreciated from above. Tom's superb painting of a gondola on the Grand Canal is more considered and formal than the instantaneous sketch produced on the Ponte Scalzi, and the composition was assembled from a series of sketchbook studies. Considered perhaps, but not enough to distract the natural painter in him from getting on with the act of painting, the celebration of this ability to describe what is seen. It is a wonderful example of the artist's painterly ability as, using watercolour and bodycolour on Turner Grey paper, he revels in the textures, colours and tones of his subject. The easy flow of the brush is entirely suitable for capturing the movement of the water and the choice of colour and tone for each mark is resoundingly sure.

Tom Coates was born in Birmingham in 1941 and studied at the Bournville School of Art, Birmingham College of Art and the Royal Academy Schools. He has taught at a number of art colleges and is President of the Royal Society of British Artists. His work in a variety of mediums and of a variety of subjects, from landscape to portraiture, has been exhibited widely in Britain and the United States, and he was the first winner of the Singer and Friedlander watercolour award. Tom, who lives in Hampshire, was elected an Associate of the RWS in 1983 and was made a full Member in 1985.

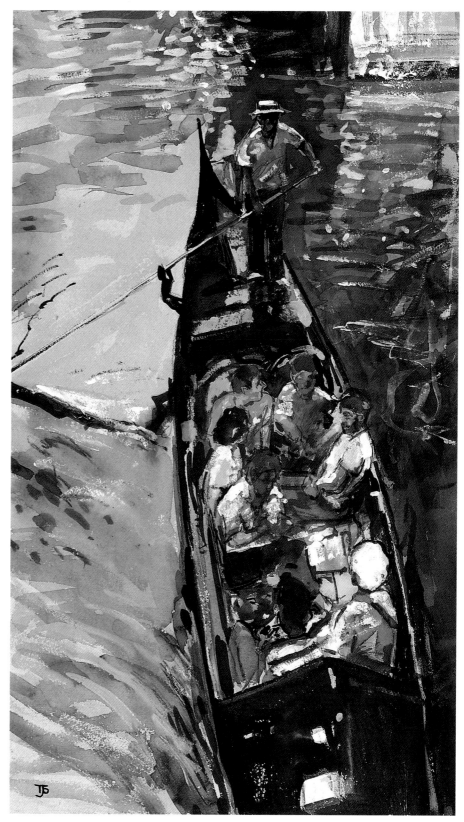

JOHN DOYLE

John Doyle is an avid traveller who, in the tradition of the eighteenth- and early nineteenth-century grand tourists, revels in the discoveries he makes and enthusiastically records them on paper. His characteristic enthusiasm for the Italian cities brings to mind the heady descriptions of earlier travellers:

There are two cities in this world that are supreme among all others – Rome and Venice. Which is the most beautiful I can never decide; when in Rome it is Rome, when in Venice it is Venice. Both are rich in the unexpected; round a corner, down an alley and some fantastic, crumbling, rich surprise awaits.

In Venice the miraculous association of Piazza to Piazzetta, the Basilica San Marco to the Doges Palace, all woven together by light and water, have provided the artist with magnificent compositions from the moment of their completion: in Rome it is I suppose the Forum. It is therefore to seek out little unknown corners in both these cities, that becomes the challenge that is so intriguing.

The painting here is of an odd corner, tucked away behind the Marine Station at the end of the Zattere. The dull red-brick building that closes the composition on the right-hand side of the picture is in fact the Dogana. The canal leads the viewer down it, past the twin towers of the San Raffaelle to the distant Campanile of Santa Maria della Carmine; it is just possible to see the Madonna standing upon her crescent moon.

One of the reasons I painted this view was the grass in it, although I probably was not aware of it at the time. There is not much grass left in Venice and therefore when you find it the combination of brick and bridge, church and water, is made more intriguing by a bit of green.

Really the painting is a homage to the dying light of a summer evening. 'Rage, rage against the dying of the light.'

The Church of San Angelo Raffaelle, the twin towers of which are to be seen in the background of John Doyle's watercolour, was built by Francesco Contini after 1618, although the existing façade was erected in the 1730s. Dedicated to the angel who guided Tobias on his epic journey, the church is one of the many which have recently been the subject of restoration. It is set on a campo in a quiet district of Dorsoduro, not far from the Zattere. The artist has taken the view from beside the Rio San Nicolo, along the Rio dell'Angelo, with a customs building in the right-foreground of the scene. As the photograph of the view demonstrates, the artist here presents us with a topographically accurate record.

John Doyle is without question an artist of the topographical tradition. It is probably right to define his position even more precisely as being in the classicising, Claudian branch of this tradition. His is the lineage of painters such as Richard Wilson, Thomas Jones and, to an extent, John Varley, rather than the more picturesque English tradition of draughtsmen like Thomas Hearne, Edward Dayes or William Callow. His frequent use of gouache, his love of the bright Mediterranean light and the balanced compositions of

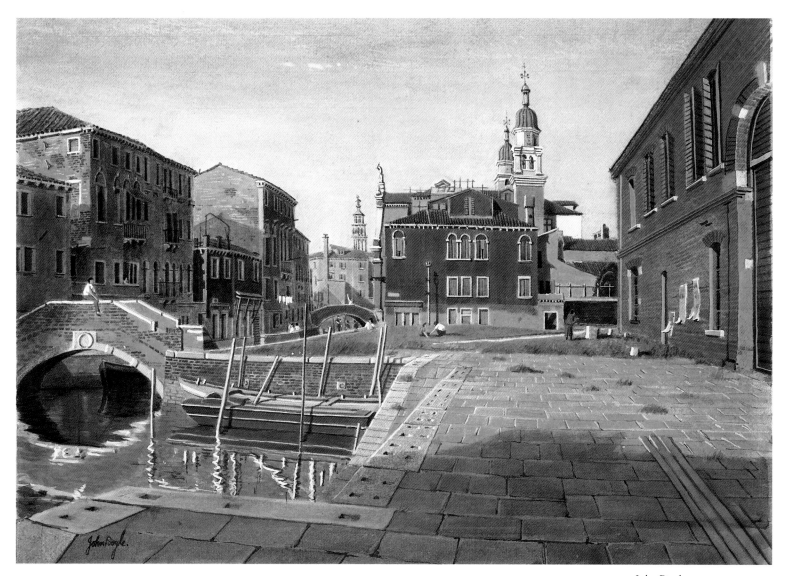

John Doyle
RIO DELL'ANGELO

his often southern subjects all lend weight to this judgement. He is indeed a painter of the light of the south.

There is, in fact, a direct clarity to John's work that conveys with it a sometimes disarming honesty with his subjects. There is a feeling that once the view is chosen, the composition a happy one, he simply gets on with laying its image on the paper – revelling all the while in the gorgeous colours and architectural curiosities, but never dreaming of allowing artifice to impinge upon his work. It is an almost innocent wonder at the beauty of the world that emanates from his pictures, be they of Venice, Chianti, India or the Thames Valley. On most occasions, when surveying his work, the impression comes over that the artist exclaimed with his exemplary fervour that he just had to sit down and paint this wonderful view.

It may indeed be in the character of the man, but another thought does come to mind. He was advised by distinguished artist friends, and he did attend evening classes, but John Doyle is essentially self-taught. He is no primitif, like Douanier Rousseau, but it may be that, untrammelled by an art college education and unhampered by the weight of its theoretical, formal and technical know-how, his art bears an uncontrived freshness, an absence of the world-weary formality that can deaden true creativity.

Another pleasing example of John's direct approach is the small gouache study of one of the classic views across the basin of San Marco from beside the Dogana to the island of San Giorgio Maggiore. Here the artist is less concerned with architectural accuracy than with capturing the pink sunrise over the Riva degli Schiavoni. This painting of light echoes the scene that Henry James described in *Italian Hours* when trying to explain the visual success of San Giorgio:

> It is a success of position, of colour, of the immense detached Campanile, tipped with a tall gold angel. I know not whether it is because San Giorgio is so grandly conspicuous, with a great deal of worn, faded-looking brickwork; but for many persons the whole place has a kind of suffusion of rosiness. Asked what may be the leading colour in the Venetian concert, we should inveterately say Pink, and yet without remembering after all that this elegant hue occurs very often. It is a faint, shimmering, airy, watery pink; the bright sea-light seems to flush with it, and the pale whiteish-green of lagoon and canal to drink it in.

The study is simply painted with brief strokes of the brush on a tinted and colour-washed paper that does a lot of the work for the artist. Having first laid an appropriate pink wash across the upper half of the grey paper, John then builds up from this tone in white and tinted bodycolour to form the highlights and down in a darker mixture to represent the buildings on the Riva and foreground elements of the scene. It is a happy, unpretentious sketch of the scene in the clearest manner that the artist can find.

Rio dell'Angelo from Fondamenta di Pescaria

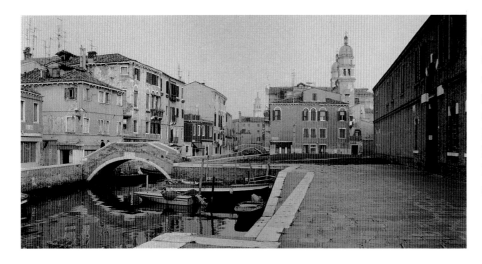

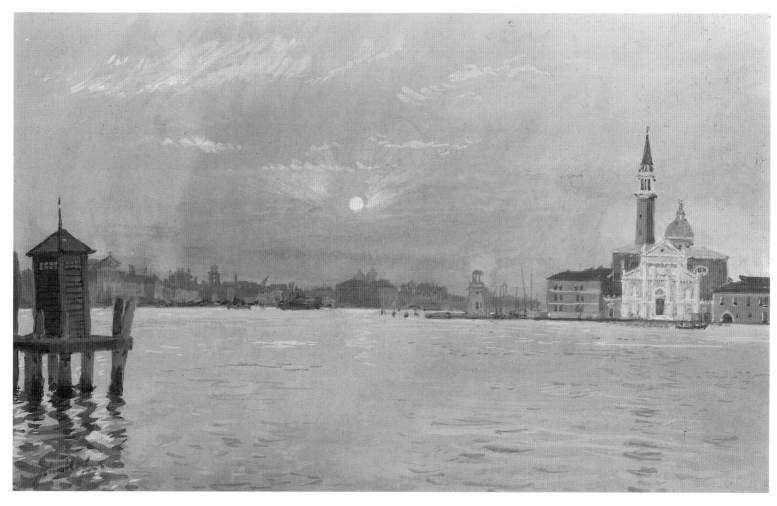

John Doyle
SUNRISE – SAN GIORGIO
The jetty on the left is also the
subject of a watercolour by
Hans Schwarz page 107

John Doyle was born in London in 1928 and the early part of his working life was spent in industry. After some amount of self-tutelage, he turned to full-time painting in the early 1960s. He is a painter of land and townscapes, principally in southern England, France and Italy and has produced a book of paintings of the Thames Valley. One of his commissions was a picture of Canterbury Cathedral for Archbishop Coggan to present to the Pope. He has held a number of extremely successful one-man exhibitions at London galleries and elsewhere. John, who lives in Kent, was elected ARWS in 1977 and a full Member in 1983.

HARRY ECCLESTON

November 1989 was Harry Eccleston's first Venetian expedition. As an artist so cultured in the aesthetics of some of the most notable painters and etchers of the city and its open spaces, this first encounter with La Serenissima was as intimidating as for any of the other first-time visitors. Bearing in mind his exquisitely delicate, even minimal accounts of the English coast, it had seemed that the open waters of the Lagoon would be of interest to this former naval man. Remembering a time spent enjoying the view from the café at the entrance to the Biennale in the Giardini Pubblici, I suggested to Harry that he, too, might like this grand panorama of Venice and the islands to the south-east. I awaited the verdict with not a little apprehension:

As someone brought up on Turner and Whistler, I approached Venice with some trepidation. It was particularly so, because looking at all of Whistler's Venice etchings earlier in the year had renewed my knowledge of his vision of the city, and although I had deliberately not looked at Turner before I left, his Venice watercolours are among the works I most admire and consequently best remember.

There was also the difficulty (for me almost the 'impossibility') of really understanding in a short time any new visual experience, even a simple one. It was apparent after walking around the city on the first day that the trepidation was justified, for I saw no way of significantly conveying the wonderful excitement of the Grand Canal and knew that sadly I would have to forgo the palaces.

In such circumstances the only solution seems to be to find the comfort of something that you at least partly know, so I heeded good advice and headed to the most easterly end of the island, to a spot which must be known to all visitors to the Biennale. There the water, which is the reason for the city's existence, from which it sprang and into which it is sinking, was at least familiar.

From there I could not only see Venice itself, but also the smaller islands to the south and the beautiful San Giorgio Maggiore set against the city. The morning mist was heaven-sent, simplifying the complexities, isolating the individual islands, and enhancing the tracery of orange lights which mark the channels through the islands. It seemed that by chance I had found a subject on which I could begin.

Although one hopes that the final work will have a comparable simplicity to that of the first direct watercolour sketches, this I find can only be achieved from a mass of information. So I spent the rest of the visit in the same position trying to understand through drawing what had been hidden in the mist. On the fourth day the sun came out and the light and colour changed almost continuously, until the point at which the sun finally set. At times like these how one envies Turner his amazing 'photographic' memory (I wonder what he called it?) and the magic of his rapid statements. I could only be pleased that I had a camera, with a fast film suitable for such conditions.

Harry Eccleston's technical method is exemplary for any artist who has the capacity, patience and sensitivity to accumulate a great amount of data, to be absorbed into the watercolour painted back in the studio. As befits the artist whose many drawings formed the design concept for the currently established British bank-notes, his working processes are exacting. Following on from the initial sketchbook drawings in pencil were watercolour studies capturing the colour changes he describes. Photographs added detailed information and then, building wash by wash, constructing textures fleck by fleck with sable brushes, the final watercolours were formed on the basis of an outline pencil drawing.

The overall effect of the panoramas Harry confronted was an enormous aerial and watery space, surrounded by famous landmarks, which almost gratuitously compose the scene. On the first days of his study there, he watched the lights of the traffic lanes of the Lagoon punctuate the mist, as sky and sea melted as one. Describing a different Venetian vista, Frederick Rolfe wrote in his 1909 novel *The Desire and Pursuit of the Whole* about lights that fluttered '...like pale daffodils in a night-mist coloured like the bloom on the fruit of the vine.' The sense of space and the subtle lighting changes involved, are just as beautifully conveyed in Harry's final watercolours.

The work which principally concerns us depicts the gateway to Venice, described by the twin posts of the towers of San Marco and San Giorgio Maggiore. On that fourth day that Harry mentions, having slipped unseen on a *vaporetto* past the artist at work, I arrived on the Lido. Turning around and looking back at what had by now become 'Harry's view', I was faced by a wonderful sight in the strong, clear afternoon sunlight. Happily Ruskin also enjoyed this magical prospect and wrote about it when discussing the Palazzo Ducale:

Harry Eccleston
San Giorgio from the Giardini Pubblici

So precious, indeed, and so full of majesty, that sometimes when walking at evening on the Lido, whence the great chain of the Alps, crested with silver clouds, might be seen rising above the front of the Ducal Palace, I used to feel as much awe in gazing on the building as on the hills...

And so, perhaps, one does; but the combination is breathtaking. It is to be hoped that Harry Eccleston, who only saw the extraordinary sight of the Alps over the water on his leaving of the city, will be able to develop into one of his celebrated series his images of the life-enhancing open waters of the Venetian Lagoon. It is entirely within keeping that men like Byron, Shelley and Ruskin crossed these waters to relax on the Lido. This remarkable passage of sea is the watery equivalent to the most romantic windswept English hill-top. Besides the splendid views that Harry's

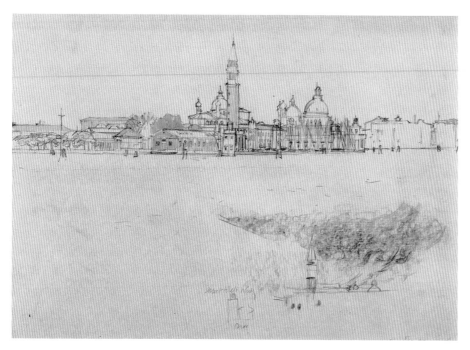

Harry Eccleston
Study for San Giorgio
and the Salute
*This is one of a series, of the
view from the Viale dei
Giardini Pubblici , which
provided the artist with the
visual data he required for the
two watercolours*

Harry Eccleston was born in Staffordshire in 1923 and trained at Bilston School of Art, Birmingham College of Art (interrupted by war service in the Royal Navy) and then at the Royal College of Art. After teaching at Barking College of Technology he took up the post of Artist/Designer at the Bank of England printing works and was awarded the OBE for his work on the Bank's Series 'D' notes. As a distinguished printmaker he served as President of the Royal Society of Painter-Etchers and Engravers (RE) from 1975 to 1989. Harry, who lives in Essex, has exhibited his watercolours and etchings widely. Having been elected ARWS in 1964 he was promoted to RWS in 1975.

position afforded, there were other compensations in being located here:

The chosen spot had other advantages, for although I spent many hours there, using the sea wall as the perfect desk, I only occasionally suffered from sea spray and had but two sets of visitors. The most interesting were Russians, a father and two sons who showed all the enthusiasm and friendliness we know them to have. Venice they thought was wonderful. I agreed equally enthusiastically and we parted with much clasping of hands.

Whether working in the shadow of the Biennale buildings will be a source of inspiration only time will tell, but it had one invaluable benefit – the gardens offered the perfect shelter for lighting a pipe!

Right
'The perfect desk...'

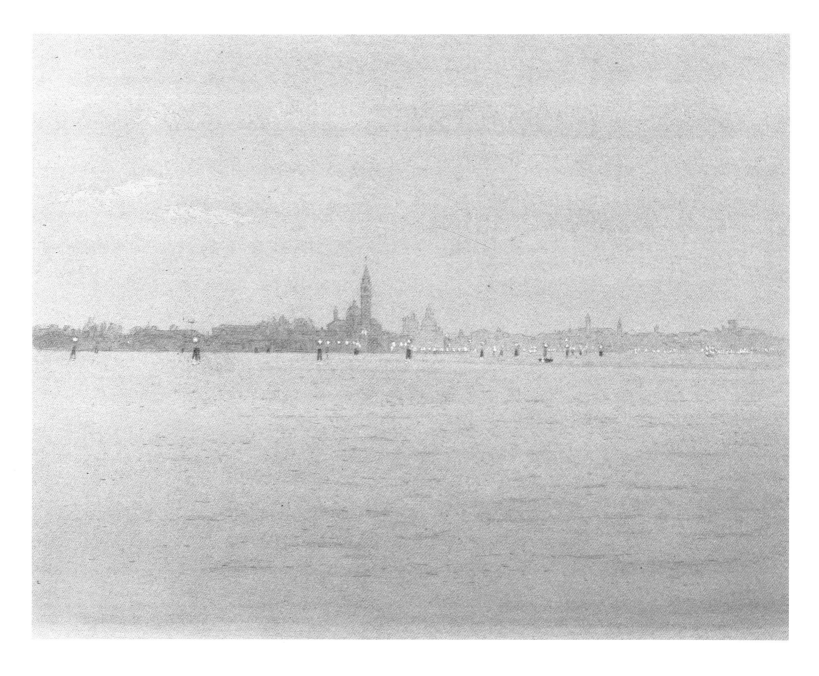

Harry Eccleston
SAN GIORGIO AND THE SALUTE
FROM THE GIARDINI PUBBLICI

WILFRED FAIRCLOUGH

Rio di San Giovanni and Rio della Tetta from Ponte Storta

Wilfred Fairclough's etchings of Venetian life have in recent decades become his best-loved, and certainly his best-known, images. In these classic works of the genre, a whole experience of the city is laid before us – musical performances at the Fenice, boat trips to Torcello, the chef and his diners, preparations for the carnival, priests strolling in the rain, among many other subjects. His watercolours of Venice are less well known, but can be just as striking. I found particularly powerful the watercolour illustrated here of the two bridges at the junction of the Rio di San Giovanni Laterano and the Rio della Tetta, taken from the Ponte Storta.

I asked Wilfred whether this was a corner of Venice that had interested him previously or whether he had simply come across it and decided it made for an interesting subject.

I just came across it. It is actually on the way from Santi Giovanni e Paolo to the Arsenale. This seemed to be something different, and quite interesting that there are two vistas and this great slab in the middle.

How did he go about the water colour?

I always make drawings of some sort and then I take photographs – black and white photographs. All I want is information. With black and white, you can do whatsoever colour you want.

Wilfred went on to tell me that he found colour photography too compelling for this purpose, that it has a tendency to dictate to the artist the choice of colour to be used in any subsequent sketch or finished work. Even the monochromatic records he now makes with the camera would not have been envisaged in his youth, when, as a Rome scholar, he first explored and drew the cities and towns of Italy.

Early in his career, Wilfred Fairclough would have made extremely precise preparatory drawings of a subject such as this. I wondered whether the information gathered in his photographs would differ from that recorded in such a drawn study, also made before the subject.

No. You've seen my sketchbooks – I couldn't possibly do that now, it's too much hard work. So I use a camera in exactly the same way as I would use a sketchbook and for exactly the same purpose. From the same position I may take a dozen photographs – of the same thing,

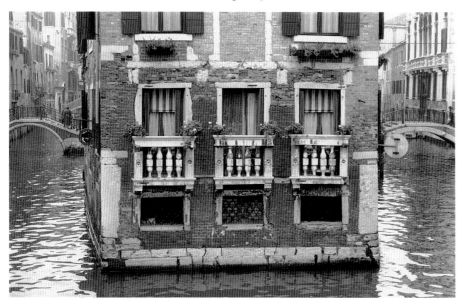

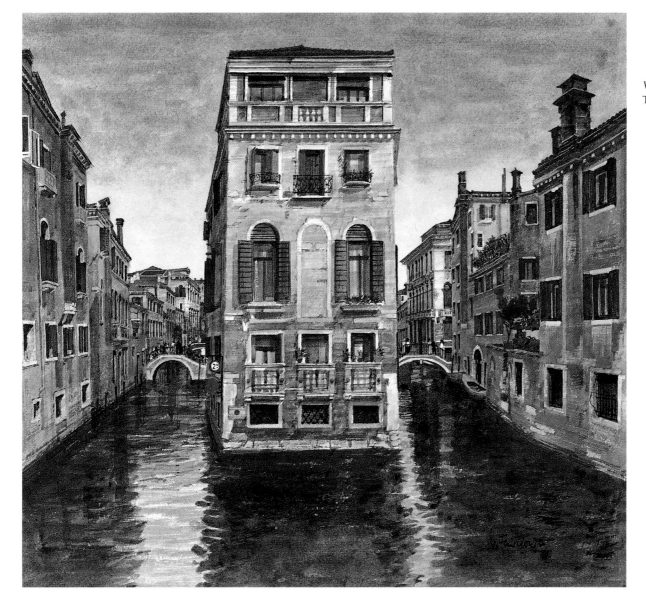

Wilfred Fairclough
TWO BRIDGES – VENICE

apparently – but there's something else that has happened, and that is further information. If I was drawing in a sketchbook I would either make a note of it on the bottom of the sheet or I would put it straight into the drawing.

Visiting the spot in November 1989 – armed with a transparency of Wilfred's studio-painted water-colour – I was struck by the wonderful truth of his drawing and the extraordinary veracity that his dryly brushed layers and washes of watercolour give to the subject. I was particularly impressed by the accuracy of the colouring, taken as it was from a brief sketch with colour notes. Clearly, the ability to translate these notes so faithfully is aided by a lifetime of observation, as well as a sharp visual memory:

It's an interpretation. Most of these notes you see are very vague – pinkish, yellowish grey – what has to be got is something that works in the drawing. It will approximate to the colour of the building, but it will be that little bit different, because it's got to be orchestrated into the drawing.

So, for all its crisp detail and, to my eyes at least, precise colouring, this is not pure topography?

Oh no. I sponge out quite a lot, wash out and put in. If one thing doesn't work I do something else, until I get it right. That's how I work. I'm glad I don't have miraculous technical facility. If it's technique simply for the sake of technique, I am not interested. Whether I'm doing drawings, paintings or prints there has got to be something else. Technique is the servant of what I'm trying

to express, and of course I bend it where I find it's necessary – there's no set method. There is a progression, otherwise you get disorder. But technique is a servant – full stop.

Having supposedly absorbed this message, and recognising that his undoubted technical skills were as much as anything based on superb draughts-manship, I wanted to ask Wilfred about the wonderful tonal studies that fill his Venetian sketchbooks. Was he using a coloured pencil?

No. Usually I carry a bit of chalk around with me – it's natural chalk, not conté. I saw it up with a hacksaw into small pieces and I just hold it in my fingers. The advantage of using natural

chalk is that I can sandpaper it to a really fine chisel edge, which gives me all these fine lines, and then to do the tone. I just turn it sideways and scrub away. It's very hard and, of course, being hard it keeps its sharpness.

This is the traditional, classical red chalk, with which Watteau did his drawings. It puzzled me for a long time how Watteau could draw knuckles in a hand with such precision.

How had he gone about making the exquisite detailed pencil studies of the roof-tops of Venice from atop the Campanile?

For this kind of very detailed drawing I use a very hard pencil – an H, 2H, something like that. I lay out the whole design in the broadest terms, rather like an architect putting down a building on a piece of ground. He does all his major movements, where this corner and that corner are to be, and then from there he will move into the bits and pieces. I did this in exactly the same way. I drew this slab and I drew the main movements of this and then I developed it. The important thing is to start with a good foundation, to make absolutely sure that the foundation is right, cross-checking this way and that way.

All that was done on the spot. Somebody looked at me and said, 'Gee, that real works'.

With a craftsman and artist of the calibre of Wilfred Fairclough, it will indeed work, as the consummate drawings from the Campanile show. The striking subject of the two bridges is a drawing of equal control and a watercolour of great sensitivity. That the perceived image is one of truth and simplicity is testimony to the stature of the artist and his experience.

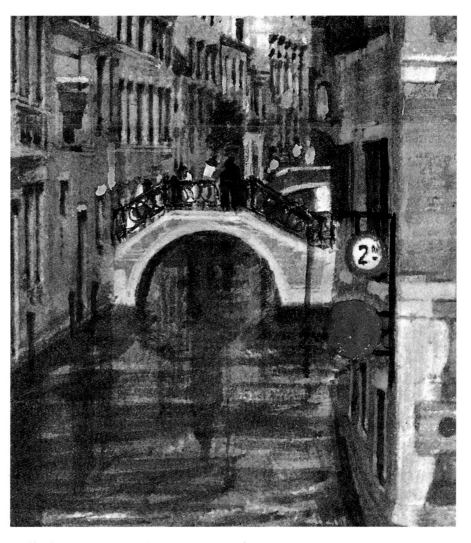

Wilfred Fairclough was born in 1907 and trained at Blackburn School of Art, the Royal College of Art and the British School in Rome. He became Principal of Kingston College of Art and Assistant Director of Kingston Polytechnic. His celebrated etchings, and of course his watercolours, are in all the major national collections, and he has had numerous one-man exhibitions around Britain. Wilfred, who lives in Kingston-upon-Thames, was elected ARWS in 1961 and a full Member of the Society in 1968. As an important etcher, it is worth recording that he was elected ARE in 1934 and a Fellow of the Society in 1946.

Wilfred Fairclough
Two Bridges – Venice, detail
Fine draughtsmanship with the brush

71

DENNIS FLANDERS

Dennis Flanders must be one of the most familiar of topographical painters and draughtsmen of the post-war years. His fine records of celebrated and lesser-known town and landscapes from around Europe have been seen in a wide variety of exhibitions, periodicals and other publications. The controlled swagger of the pencil line is an inimitable hallmark, as is the classical composition and subtle washed-in colouring. In other words we find in this artist the true inheritance of the Grand Tour and the great age of the topographical watercolour, of Thomas Hearne and Francis Towne, of Thomas Malton and John 'Warwick' Smith.

The splendid drawing of Santa Maria della Salute, taken from the edge of its campo, is a fine example of how the artist works. Dennis explains how this famously grand subject was tackled:

The starting point of the composition is a group of houses, of red brick and pantiles that occupies the centre of the picture. These are made particularly beautiful in the early morning by the fretted shadows from the silhouette of the Salute, which occupies the left-hand side of the work. I have always loved the church of the Salute, with its Baroque features, statues and curved buttresses, supporting the dome, pillars and long flights of steps, and always try to make another picture of it every time we go to Venice. But many purists look down their noses at the Salute – it's in bad taste they say, preferring the 'purity' of the Redentore, which I find very cold and have so far avoided painting!

To the right, there is so much detail that the balance of the composition is well preserved: the canal itself, all the many palaces, distant views of the Accademia Bridge, the many *pali* and above all the broadening of the stone pavement and landing stage, right across the base of the picture, give a real strength.

As you can see from the preliminary sketch (which is full-sized and used for tracing the main lines of the finished picture), more or less all the 'sections' have been indicated and exactly carried out. After years of experience I have found that the original design, done in the heat of the moment, can never be improved upon.

The various verbal notes are written in on the sketch in case one is unable to come again, or that the same weather conditions may not recur. Four or five mornings were, in fact, devoted to this work – and of course a few days at home spent in cleaning up mistakes and generally finishing it off.

The finished watercolour represents an authoritative understanding and binding together of the elements of this difficult composition. The artist has found that his desired arrangement of these elements is to be obtained from a viewpoint by the edge of the Grand Canal, which is also out of the way of passing pedestrians. It may be noted from the photograph that while the artist has remained entirely faithful to his subject, he has without any apparent exaggeration strengthened the complex perspective, thus intensifying the drama of the scene. The photograph also shows that to obtain this vista the artist has had to position

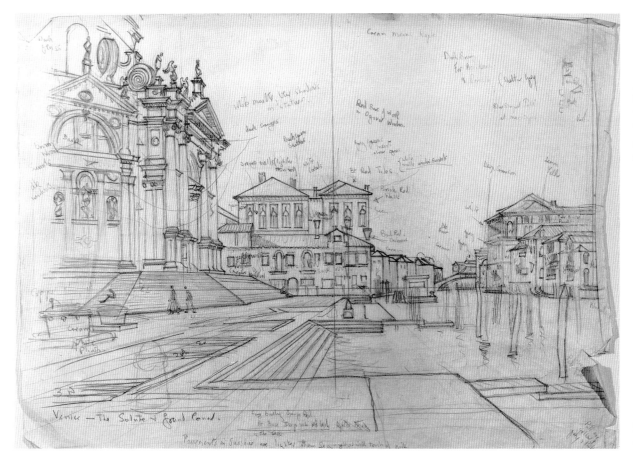

himself behind an intrusive lamp post, which has been omitted from the full-scale drawing of the subject, although its base appears in the finished work.

The artist's experience and knowledge of the architecture of Venice have given him an enviable ability to translate into line the most complex shapes of these famous buildings. As Dennis explains, the whole scene is recorded using the time-honoured method of translating the full-size, on-the-spot drawing to the final sheet. The watercolour washes, which bring the whole scene to life, are laid on to the drawing only once the firm architectural structure is achieved.

Despite his skills, Dennis had some trepidation about tackling a vista of the Basilica San Marco that he came across when walking through the most southerly arch of the Ala Napoleonica:

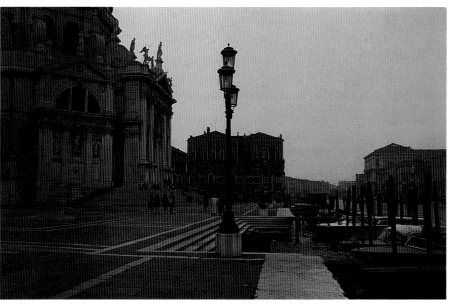

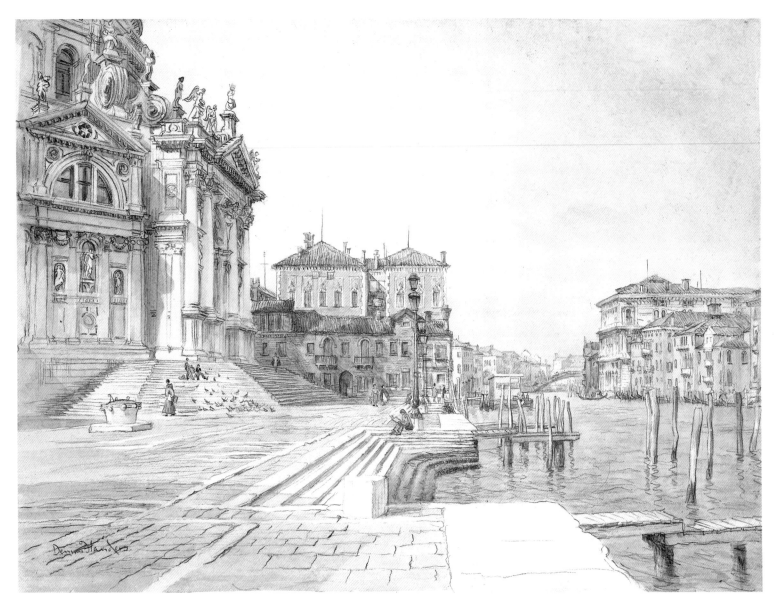

Dennis Flanders
THE SALUTE AND THE
GRAND CANAL

This subject I found gigantic, but irresistible.
Although I had seen many pictures by many
artists of the Piazza, when my wife and I actually
walked along a narrow alley and saw, for the first
time through an arch, the famous view of the
Campanile and the domes of San Marco, I gasped
with delighted amazement, for the scene seemed
much more beautiful than I thought possible.
And thus it was, and I knew in a flash, that I

would have to draw it from that very spot –
however awkward I knew it would be, standing
up among the constant comings and goings of all
the people. To ease matters, I placed my stool
and other articles of paraphernalia in front of the
pillar on the left, where I could keep an eye on
them and could work with comparative ease.
From time to time I would move forward in order
to sit down on the stool, rest, paint, and use my

flask. Napoleon was quite right when he said the Piazza San Marco was the finest open-air drawing room in Europe – and who would contradict that?

A week or so of afternoons (for that was the time when the shadows seemed best) were spent on this subject, for there was a lot to do and I felt it all worthwhile.

The photograph of this view shows that the artist has diminished the scale of the figures in order to exaggerate the scale of the fine arch. This grandeur and the presence of the figures as onlookers also serve to emphasise the artist's – and thus his viewer's – wonder at the splendour of the sight. The practice of introducing such scaled-down onlookers to intercede, as it were, on behalf of the viewer to increase his sense of awe, is entirely within the watercolour tradition and was employed by artists from Towne to Turner and beyond. Turner in particular was also in the habit of distorting topography to express some perceived truth or emphasise some notable quality in his subject matter. Dennis is clearly an artist who wishes his audience to see a picture that justifies such a venerable subject. This is a vista that had a similar impact on Ruskin, writing in *The Stones of Venice*:

Beyond those troops of ordered arches there rises a vision out of the earth, and all the great square seems to have opened from it in a kind of awe, that we may see it far away – a multitude of pillars and white domes, clustered into a long low pyramid of coloured light; a treasure heap, it seems, partly of gold, and partly of opal and mother-of-pearl, hollowed beneath into five great vaulted porches, ceiled with fair mosaic, and beset with sculpture of alabaster, clear as amber and delicate as ivory...

Dennis Flanders
SAN MARCO AND THE CAMPANILE

With the writer's equivalent of the zoom-lens, Ruskin goes on to survey the façade of the Basilica in rapturous detail. For the while, however, we will rest in the corner of the Piazza with Dennis' splendid drawing and contemplate the enormity of the vision.

Born in 1915 in London, Dennis Flanders studied at the Regent Street Polytechnic and has spent his whole life drawing and painting, often in Venice and in other European locations. He has exhibited widely, but particularly in the City of London, where his work is extremely well known and of which he is a Freeman. He has illustrated many publications, including a book about his career, Britannia. *Dennis, who lives in central London, was elected an Associate of the Royal Watercolour Society in 1970 and a full Member in 1976.*

Piazza San Marco from the Ala Napoleonica

CHRISTA GAA

During the group visit to Venice in November 1989 it soon became apparent that for anyone with the intention of making some creative appraisal of the city, the prospect of the first visit was a daunting one. This was equally true for Christa Gaa when, as a young graduate in the history of art and a painter in her own right, she paid her first respects to the Venetian heritage of which she was only too aware:

I was about twenty years old when I started to travel in Italy. Already, during my school-time, I got to know it a little through the works of writers, and my rather romantic ideas about the country were not disappointed. I loved the

Campo Santa Margherita

landscape, the old historic towns, the works of art, the language and the people, with their wild gestures and spontaneous warmth.

But for a long time I was reluctant to travel to Venice as I was afraid that it might be too beautiful and unreal – an extinct town dominated by tourism.

When I finally saw Venice, not rushing from place to place, but with the desire to paint there, I quickly fell for its charm. I always try not to spend too much time around San Marco or the Ponte Rialto, because I feel disturbed by the groups of tourists following their umbrella-wielding guides.

We stay near the Campo Santa Margherita and there it bubbles with Venetian life. Already, early in the morning, housewives are viewing critically the produce on fish and vegetable stalls, elderly people are sitting on benches having a *chiacchier-ata* [chatter], children are playing or accompanying their mothers whilst shopping and cats watch the scene from a secure position.

If possible I sit on my drawing stool with my back against a wall, because I am irritated when conscious of spectators looking over my shoulder. Sometimes though, the subject is more interesting when I am sitting in the middle of a campo – which may turn out to be a children's football field, as happened to me on one occasion, when the ball passed several times close to my head and finally landed in my water container.

The Italians are always interested in painting. They often come to a standstill and provide the

suffering artist with an encouraging *auguri*, while the children, even before they succeed in catching a glimpse of the picture, burst into an enthusiastic '*bella*!'

One has to work quickly, not only because the fishmongers take down their stands at lunchtime and try, joking and abusing at the top of their voices, to wipe out the traces of their trade with a lot of water, but mainly because the sun constantly changes the scene.

We are already becoming aware that artists react in differing ways to the presence of onlookers. Whether nonchalant or bold, secretive or timorous, their reactions to intrusions can inevitably have an effect on the nature of their work. It may be that the less brazen will sketch before the subject, later working up a painting in the privacy of the studio, or will work discreetly on small sheets of paper. Those who can shut out the world or even enjoy the familiar banter, may be able to make workable paintings on the spot. This is not to preclude the element of choice and, of course, all good artists will do what suits them and will work in the manner they feel most appropriate for their needs. In any case, there is inevitably some direct correlation between their working methods and the type or scale of the work produced.

Christa Gaa is, for all her training, an intuitively sensitive painter who relies on her subject to be the direct prompt for her brush. It seems that she has not only come to love the city she had previously studied, but that she has also learnt to live with the perils of painting in a Venetian campo. She has done so because there is no alternative. The Venetian watercolours may be smaller than the splendid still-lifes executed in the studio, but they, too, have to be made directly before the subject, as she explains:

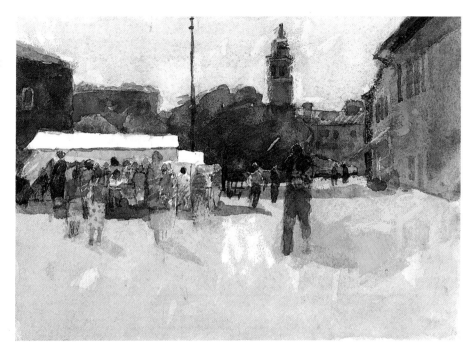

Christa Gaa
CAMPO SANTA MARGHERITA

Having drawn for a while I always start with watercolour and later I use gouache to give the picture a bit of weight. I finish a painting in front of the subject, because I believe that imagination never offers the variations of shape, colour and tone, which you can find observing nature.

The little watercolour of the Campo Santa Margherita has a fine *plein-air* freshness that is witness to the veracity of Christa's methods. Looking towards the tower of Santa Maria del Carmine against the afternoon light, the artist's presence in the campo among the market-goers is entirely believable. This work has the immediate realism of an Impressionist painting. Nevertheless, she did make a preliminary study for the composition to satisfy herself that the subject was worth proceeding with. Indeed, in the study for her watercolour of the façade of San Angelo Raffaele, we can see a formal assessment of the com-

position and the relationship of shapes and tones.

The formality of the study does not belie the richness of its qualities, particularly the unselfconscious drawing and the fine interplay of line and volume. The watercolour carries further what has been learnt in the study. It is an inspired arrangement of shapes whose associations are defined by subtle variations of tone and colour. The view is seen against the light and this enables Christa to achieve an overall concordance of effect. She has also chosen a subject with buildings at a variety of juxtaposed angles in which the varying intensity of shadow serves as the principal strength of the composition.

It is of interest to note that in taking this view of the church in the late afternoon light, Christa has decided to paint the same building as John Doyle and under similar light conditions. Looking south-west over the Rio di Santa Margherita and into the sun, she has, however, picked *her* view of the scene. John Doyle chose the clearer light of the topographical view painter. Christa's work is scarcely topographical – it concerns itself far more with the act of painting. In this way she seems to be a direct descendant of the great German expressionists and colourists of the early decades of this century. The sometimes sombre and meditative, sometimes vibrant, textures and colours of her work bring to the institutions of the British still-life and landscape an intuitive and expressive colour sense.

Christa Gaa
S tudy for R io di S anta M argherita
Made on the spot, immediately before embarking on the watercolour, this study was made to assess the composition and relationships of forms

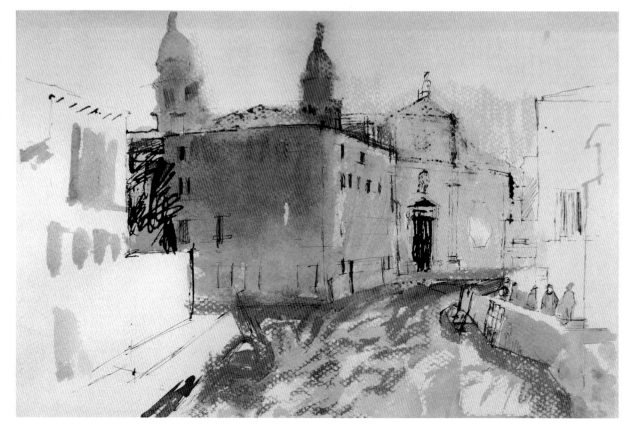

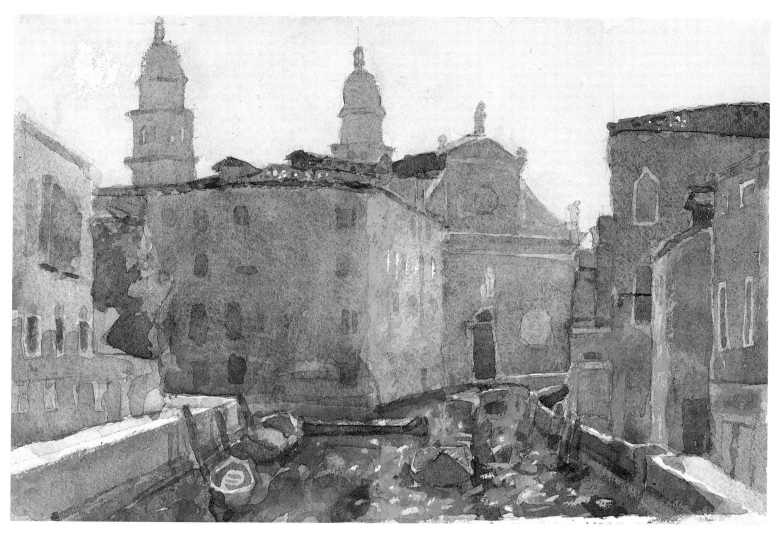

Born in Hamburg in 1937, Christa Gaa studied Ger-
man philology and history of art in Cologne, Bonn and
Florence, and finally, between 1976 and 1980, she
trained as a painter at the College of Art and Design in
Cologne. Her work has been exhibited widely in
Britain and West Germany. Elected an Associate of
the Royal Watercolour Society in 1986 and a full
Member in 1989, Christa has lived in London, Devon
and Cornwall since 1980.

Christa Gaa
RIO DI SANTA MARGHERITA

TOM GAMBLE

Tom Gamble
VENETIAN STUDIES
*Three of the splendid
watercolour studies made
by the artist in a large
sketchbook, on his travels
around Venice*

On the November 1989 visit, Tom Gamble was one of the most tireless workers, picking up where he left off from a recent visit to prepare subjects for this project. In a large sketchbook he produced a series of superb pencil and watercolour studies of views in the city, seen with his independent eye and spiky brush-marks, but recognisably paintings of *views*. But these were only preparation for more elaborate conceptions.

Tom's watercolour of a stormy, wind-swept day in the Piazza San Marco is far from being a view of the scene, nor is it quite the sort of atmospheric painting which uses the topography as a background. Its principal subject is, in fact, the carnival and how this extraordinary vestige of the Venice of the past haunts this bizarre city. This is how the artist describes the sensations which led to his particular vision of the city:

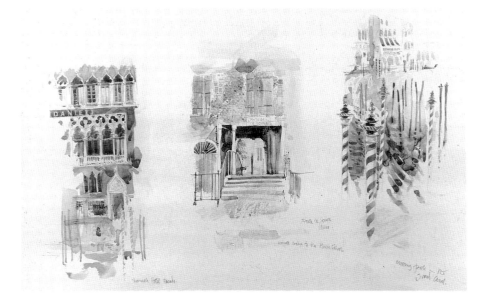

My first impressions of Venice were of its extraordinary aesthetic appeal. Philippe de Commynes, at the end of the fifteenth century, described the Grand Canal as the most beautiful street in the whole world. It is a place where time seems to have stood still.

Once free of the heavily populated tourist area, in quiet streets, squares and courtyards, one begins to sense that some great drama is about to commence. The city has a sort of deceitful beauty and below the surface one can feel a sinister aura of decadence, deeply disturbing and in complete contrast to the trivial gaiety of the holiday multitudes. Towards evening when the crowds have dispersed I become more conscious of this, with a strange atmosphere pervading everything. The quiet pacing of a stray cat, the sudden appearance of a solitary hurrying Venetian crossing a deserted square, or appearing dramatically from or disappearing into a darkened side street, heightens the sense of apprehension. Somehow, certain city people were gathering in some quiet court for the celebration of some strange ritual.

The whole decaying city appears as one gigantic theatre, divided into several stages with buildings and canals as sets for some imminent performance. Crowds of tourists neutralise this feeling, but when the crowds have gone and the city is quiet one is again aware of being drawn back once more to witness as a spectator some spectacular theatrical event.

High point in the life of the city is the great

carnival which precedes Lent and which is a monstrous celebration of eating, drinking, dancing and lust. Every performer is attired in costume and wearing a grotesque mask which disguises the identity of the participant.

Visually Venice is a city of light, the sky permanently echoed in the watery streets. Somehow time seems to stand still and one is anchored in a past century. The colours of Venice are earthy ochres, reds and greys with textures created and emphasised by decay. Line and pattern are powerful elements in the form of iron grills, fanlights, balustrades, mooring posts and television aerials. At first one is stunned by the incredible topography of the place. Buildings emerge from a watery base. It is only after traversing the length and breadth of the city that discrimination between the several visual events begins to take place and the process begins of recording impressions through drawing and painting of this beguiling and beautiful city. However, the strange undertones of the place never quite disappear and one has the constant feeling of being watched and that at any time one may become drawn into the drama of a permanent carnival and absorbed into the mystery of the incredible place that is Venice.

From these vivid impressions the final concept of my painting became clear.

For all his affability and infectious humour, Tom Gamble's reactions to places are thoughtful and deeply held. This sensitivity to the underlying mysteriousness and sense of concealment the city holds is something the commercialism of the carnival and the enormous influx of tourists it engenders do not manage to destroy. But it is in those quieter *calli*, or down

a dead-end beneath an archway in the more remote quarters, that one very easily begins to feel a sense of unease. Shadowy figures pass fleetingly across one's path, a sudden noise shocks in this most clearly acoustic of cities and then one realises that any sense of direction has evaporated. It is at times like this that images from Daphne Du Maurier's chilling tale *Don't Look Now*, or Ian McEwan's macabre novel *The Comfort of Strangers* come to mind.

Venice, however, is much more than such thoughts and fears, and so too is the carnival itself. In its present manifestation, *Carnevale* follows earlier

Tom Gamble working in the Piazza San Marco

traditions which steadily were revived during the 1970s, growing from a spontaneous fancy dress party for Italian visitors to Venice to become a huge, officially organised tourist festival. It now commences with a masked ball in the Piazza on Shrove Tuesday and lasts for a week.

In the late sixteenth century, John Evelyn had described the '...folly and madness of the *Carnevall...*', an often violent, debauched feast of music, gambling, commedia dell'arte and bull hunting. Towards the end of the eighteenth century the carnival began immediately after Christmas and lasted right until Shrove Tuesday, when fireworks were set off and the closing ceremonies were held before the doge in state. During this time every class of Venetian could hide behind a mask, allowing for those who desired it a wicked freedom. For Byron the carnival was a time of '...fiddling, feasting, dancing, drinking, masking, And

other things which may be had for asking', and during it he resolved '...to work the mine of my youth to the last veins of the ore, and then – good night.' By the time the Ruskins visited the city, then under Austrian occupation, the carnival was but a shadow of its former self.

In his watercolour, Tom shows an innate grasp of his medium. Vigorously washed, or carefully drawn, he uses it in a controlled manner to convey a rich variety of sometimes dissonant textures, patterns and moods. In this idiosyncratic manner he conveys a feeling of the very peculiarity of the scene. A few strange figures masked beneath *tricorno*; a poster of a Modigliani portrait against the side of a stall; a curious sense of desolation beneath the looming clouds – this mysterious painting is not easy to read. It is as if the meaning of the picture is being concealed from us behind a mask.

Tom Gamble
VENETIAN STUDIES
These studies of the Ca' d'Oro and a carnival figure echo the atmosphere of his watercolour of the Piazza

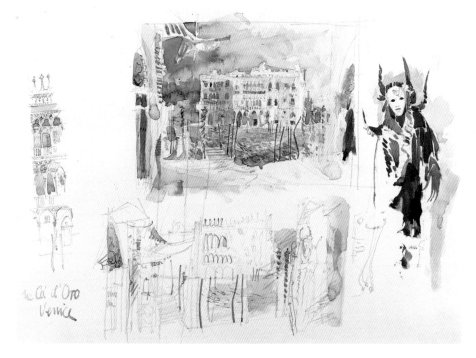

Born in 1924, Tom Gamble served in the Royal Navy in the latter years of the war and from 1946 completed his training in lettering, design and decorative painting; he has since taught these subjects at Loughborough College of Art and Design. He has exhibited widely and has work in collections in Britain, the USA and West Germany. His commissions have included designs for stage sets and costumes for productions of Comus *and* Cupid and Death. *Tom, who lives in Cambridgeshire, was elected an Associate of the Royal Watercolour Society in 1987 and a full Member in 1989.*

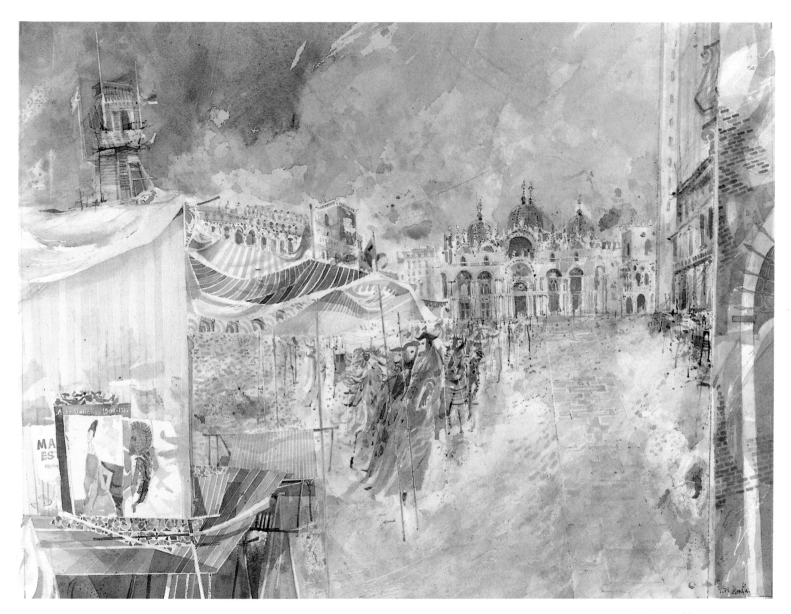

Tom Gamble
PIAZZA SAN MARCO
DURING CARNIVAL

KEN HOWARD

Ken Howard is a painter whose work of the last few years might be assessed with reference to a few dominant subject themes. There have been the drawings made in Asia and Northern Ireland with the Forces, the Cornish beach paintings and, most recently, the fine series of studio pictures, painted in the room where another great master of the brush, Sir William Orpen, once held court. More than anything, Ken's work has recently become synonymous with Venice and, as far as some are concerned, vice versa. This, however, has not always been the case:

My love affair with Venice started way back in the Fifties when I was studying in Florence and travelled up on an old motor scooter. Being young, I had the preconceived idea that Venice was over-painted and hackneyed. For me, at that time, beauty was industrial North London and I well remember that the only subject I wanted to draw was the railway siding as I approached the Piazzale Roma. But the seed was sown and over the next years germinated inside me and began to flower. When I returned some years later, my youthful prejudices had passed, but I still felt the need to paint something overtly different. The dark railway sidings with their wires running through the sky were turned on end and I painted the dark, narrow alleys, never the luminous campi.

During this time Venice was revealing itself to me and after several annual visits I really saw it for the first time and felt in some small way I could give it my own imagery. I have always

believed painters should show people subjects and enable them to see in the painter's own particular terms. Only when we ourselves have achieved this can it happen and this is never a forcing, but always a gradual process. My motivation is light, and never more so than in Venice. This I believe was the inspiration of the truly great painters of that city of light – Turner, Monet and Sickert to name but three.

Only in West Penwith in Cornwall have I discovered this particular quality and this must be the proximity of so much water, West Penwith being a narrow peninsular, Venice a narrow

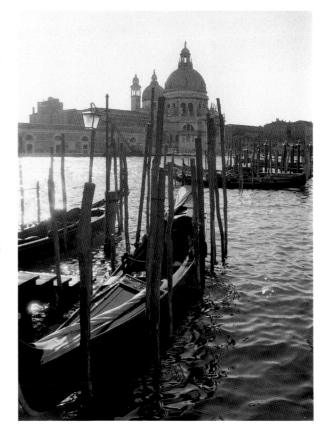

Right
Santa Maria della Salute from the San Marco vaporetto *stop*

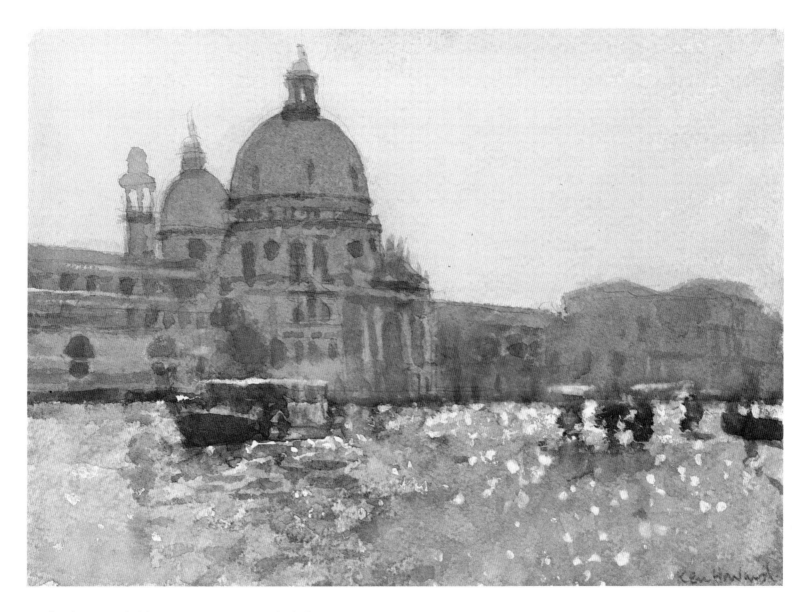

island surrounded by sea. Water creates the light and watercolour is for me the medium with which to express it.

As successive visits have unfolded I find the need to use the watercolour in a more and more pure way, never working large, for in order to capture the ever changing light the effect must be captured quickly. Venice, with its campi and narrow streets, makes one particularly conscious of the movement of the sun, and with each half hour the subject reveals something new to capture.

The two watercolours illustrated here are superb examples of the qualities which have brought such praise to Ken's Venetian work. A prolific and ceaselessly energetic artist, working on a small scale for the reasons he describes, he has over the years pro-

Ken Howard
THE SALUTE AND
THE GRAND CANAL

duced a magnificent series of watercolours. Tracing through this body of work is the artist's purposeful effort further to refine his response to the Venetian light. He is constantly reviewing and adding new vocabulary to his painterly language, always wishing to learn more from his subject. It is indeed in front of nature that this process seems to progress. Continuously working and reworking familiar subjects in ever-shifting conditions of light, he seems able to reveal to himself more and more about his art.

It is telling that Ken Howard cites the examples of three great painters of Venice – Turner, Monet and Sickert – each of whom was capable of approaching a subject in a similar spirit of determination, using it not purely for its own interest, but also as a vehicle for his own artistic investigations. Monet's analysis of a single motif in various conditions of light is particularly close in spirit, if not in manner, to Ken Howard's treatment of this particular subject, the Church of Santa Maria della Salute against the afternoon light.

This is a classic Venetian scene, but one that has proved awkward for some to paint. In describing the Salute's position at the entrance to the Grand Canal in *Italian Hours*, Henry James found a metaphor for its familiar outline:

Even the classic Salute waits like some great lady on the threshold of her saloon. She is more ample and serene, more seated at her door, than all the copyists have told us, with her domes and scrolls, her scolloped buttresses and statues forming a pompous crown, and her wide steps disposed on the ground like the train of a robe. This fine air of the woman of the world is carried out by the well-bred assurance with which she looks in the direction of her old-fashioned Byzantine neighbour; and the juxtaposition of two churches so distinguished and so different, each splendid in its sort, is a sufficient mark of the scale and range of Venice. However, we ourselves are looking away from St Mark's – we must blind our eyes to that dazzle; without it indeed there are brightnesses and fascinations enough.

In these watercolours, taken from the San Marco *vaporetto* stop, Ken Howard has undoubtedly conveyed the ample serenity of the church better than the photographer or the copyists – indeed, the church so often seems to be inaccurately drawn in paintings of every standard. It is, however, that dazzle which has caused the artist to paint and repaint the Salute; to catch every available nuance of the light as the afternoon sun dances on the water.

As Ken sat painting, the silhouettes of a host of various river craft would have passed before him – gondolas, motor launches and the *vaporetti* that zig-zag across the canal from the Salute stop. Some of

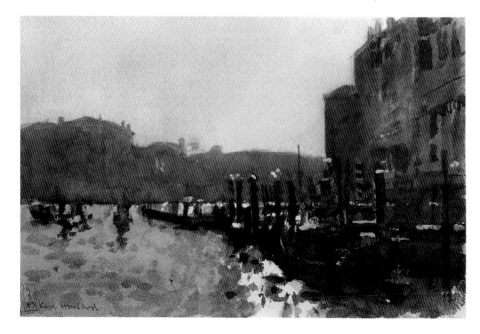

Ken Howard
GOLDEN LIGHT, VENICE
A different view on the Grand Canal from his principal works, this beautifully composed watercolour is a further example of the artist's desire to comprehend fully and express the quality of the Venetian light on water

these have been included in the artist's effective short-hand, offsetting the brilliant sparkle of the water. The whole scene is rendered with economical, impression-istic brushwork and from the rich tones and sensitively coloured washes the highlights are picked out with the judicious use of scratching out and dabs of white bodycolour.

In both cases infused with the artist's own magical touch, the results appear entirely natural and happy. Despite his painterly genius, their apparent ease of execution hides years of individual toil that have brought Ken Howard to the position of being one of the most admired painters of Venice. It might seem surprising therefore, although entirely characteristic of the artist, to learn that he does not feel he has achieved what he set out to do in the city. The process has only just begun:

> Unlike my first visit when I was full of prejudice
> and believed it was a subject which had been
> 'done', I now feel Venice is just beginning for me
> and its magic is yet to be discovered.

Born a Londoner in 1932, Ken Howard studied at Hornsey College of Art and subsequently at the Royal College. After studying in Florence, he became a full-time painter, working for some years as an official artist with various regiments of the British Army, including the Gurkhas in Nepal and periods with the troops in Northern Ireland. Perhaps his most familiar themes, in oils and watercolours, are studio interiors, beach scenes and Venice, and these have been shown in many one-man exhibitions. He has undertaken several commissions, including a portrait of the Queen. Ken, who became an Associate of the Royal Academy in 1983, shares his time between London and Cornwall. He was elected ARWS in 1979 and RWS in 1983.

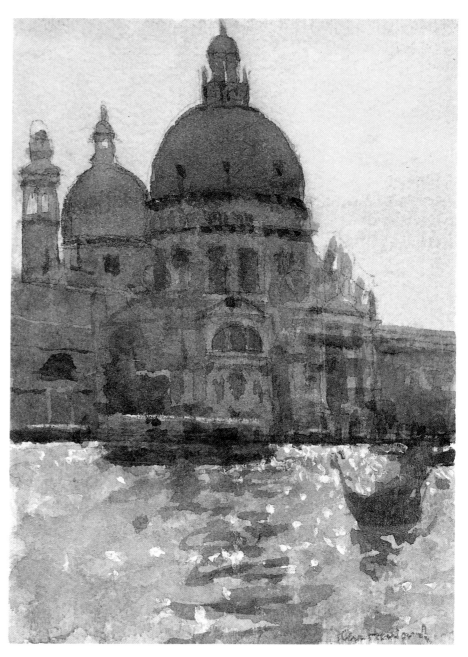

Ken Howard
THE SALUTE

OLWEN JONES

The November 1989 RWS visit was Olwen Jones' first to Venice and came a few weeks after her election to Associate membership of the Society. With her exemplary energy she reconnoitred the city, making a superb series of sketchbook drawings of details of architectural ironwork, market stalls, secretive courtyards, roof-tops from a hotel window, a flower shop and other details of the Venetian scene which interested her.

Olwen is an artist who finds pattern and design in the environment that mankind has created, often contrasting this apparent order with organic forms. This interest is evident, for example, in her watercolours and pencil drawings that are derived from observation of greenhouses, and in these she utilises the reflections in glass to enhance and add depth to her designs.

It was therefore interesting to find Olwen gravitating towards the observation of Venetian reflections – not the shimmering canals, though, but the window and mirrors of a shop selling glass and ornaments in the Ala Napoleonica at the western end of the Piazza San Marco. Here she explains what led her to the subject:

Olwen Jones working from a reflection in a shop window in the Ala Napoleonica

A few days into our visit and dazzled by the splendours of Venice I had made numerous drawings of various subjects, before homing onto my favourite theme of reflections. I was particularly interested in the Piazza's activity, which is dominated by the Basilica of San Marco at one end. Alongside the cafés and banks facing the Piazza are a number of shops selling Venetian glassware. The paradox of the old and the new interested me. The doors and windows of these shops advertise the modern world by their credit card stickers, but their past in the reflection of San Marco is ever present. I was very intrigued by the contrast, like seeing both sides of a coin at the same time.

In the picture the glass objects can just be seen for what they were, but mainly they merge into the reflection of the colonnade and San Marco at the opposite end of the Piazza. There is a certain irony about an old and well-known building set amongst the trinkets of the modern day, with the credit card placards. You pay with plastic, but no-one can buy San Marco!

Having formulated an idea about my subject, I began by making black and white drawings in my sketchbook. These could be very detailed with written colour notes. The aspect was complex, with merging levels and planes that had to be organised in the drawing before I could think about the colour. The linear and textural structure was important to the planning of the composition. These elements must also be sorted out in the drawing before I began on the watercolour

This many-faceted watercolour was made from one of a number of carefully structured drawings of the window, taken from differing angles. The photograph of the artist at work gives an idea of the varying elements which needed to be clearly understood and recorded if enough information was to be available to construct the painted image. These details would have included, for instance, the angles of glass shelves and involved an amount of selectivity as well as a strength-

ening of those parts of the design which the artist wished to be given emphasis.

The subtlety of this recording process would have been far beyond the capabilities of a camera and Olwen needed to be certain her hand and eye had absorbed sufficient knowledge of the subject. For this reason a drawing intended as a study for a painting – a means to an end – might take on entirely different characteristics from a study made for its own interest. Into this latter category would come some of the artist's earlier records of intimate corners of the city. The study for this painting is more of a working drawing, having less regard for the aesthetic result than for the potential for furtherance that it offers.

The finished watercolour is executed with a combination of washes and crisp brush strokes onto dry paper, which has in several areas been left untouched. The variety of the handling is synonymous with the disjointed elements of the subject, which are brought into a harmonious design by the artist's skilled manipulation of the composition. She manages to bring together the two most distant sides of the Piazza and compress into the picture space an array of juxtaposed images – the credit card stickers with San Marco; the public outdoor lamp with the rich glass chandelier; the arch of the colonnade reflected through two glass surfaces to stand at a right angle to itself.

In its concise and symbolic way, this watercolour is an epitome of the Piazza itself. This vast irregular quadrangle is, like the hearts of several other great city-centre meeting places, a metaphor for the life of the city. For many centuries the hub of Venetian life, the Piazza is flanked by great buildings of state, of learning, of commerce and at its apex, of God. Such an accumulation developed over many centuries, during which the Piazza itself evolved from an orchard to being paved in stone in 1722.

Olwen Jones
STUDY FOR REFLECTION ON SAN MARCO
This is the sketchbook study made in the (closed) shop doorway on a cold Sunday in November.

Long before this, during the days of Empire, Venice was the greatest trading city of the western world and the Piazza was its market. The juxtaposition there of God and mammon has a long history, as Thomas Coryat showed in his 1611 travelogue, *Coryat's Crudities*:

The fairest place of all the citie...is the Piazza, that is, the Market place of St Marke...Here you

may both see all manner of fashions of attire, and heare all the languages of Christendome, besides those that are spoken by the barbarous Ethnickes; the frequencie of people being so great twise a day, betwixt sixe of the clocke in the morning and eleven, and againe betwixt five in the afternoon and eight, that...a man may very properly call it rather Orbis then Urbis forum, that is, a market place of the world, not of the citie...

I wondered at the plenty of them [fruit]; for there was such store brought into the citie every morning and evening for the space of a moneth together, that not onely St Markes place, but also all the market places of the citie were super-abundantly furnished with them...

The Ala Napoleonica, in whose colonnade Olwen stood to make her drawing of the subject, was constructed under the dictator's orders to include a great ballroom and other apartments. In a moment of not untypical megalomania, Napoleon reportedly described the Piazza as 'The most beautiful drawing-room in Europe, for which it is only fitting that the heavens should serve as a ceiling.' Somehow, this painting is a visual transcription of that grandiose statement.

Olwen Jones was born in London and trained at the Harrow College of Art and the Royal Academy Schools. Her immense and voracious talent for drawing was recognised in her student days with the award of two RA Schools silver medals, and she also won two David Murray landscape scholarships. She has taught to degree level at Harrow and her work is in over fifteen municipal galleries in England alone. Olwen lives in a village in the Essex countryside and was elected an Associate of the Royal Watercolour Society in 1989.

Olwen Jones
REFLECTION ON SAN MARCO,
detail

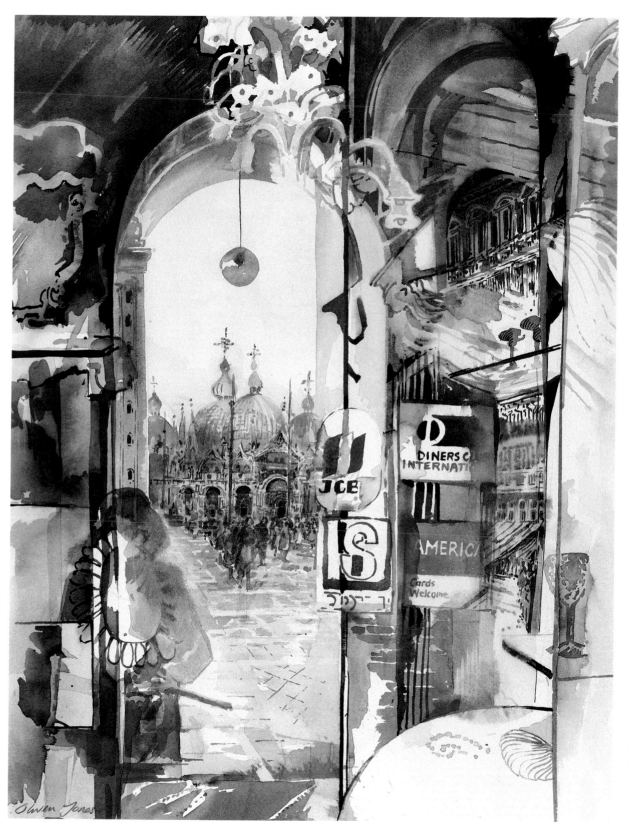

Olwen Jones
REFLECTION ON SAN MARCO

91

PAMELA KAY

Pamela Kay
SAN MARCO BY NIGHT,
MARCH

On her visits to Venice, Pamela Kay has painted a series of ambitious paintings, nearly always directly before the subject. One of the most magical of these is the dazzling view of the Basilica San Marco and its Campanile by a bright moon. This scene, under the full moon, is described in the 1833 *Journal* of Ralph Waldo Emerson as '...all glorious to behold. In moonlight this arabesque square is all enchantment – so rich & strange & visionary.' This, too, is an experience that Pamela knows:

Whenever I am in Venice, even if it is only for twenty-four hours, I feel the need to pay my respects to the Basilica, so on a velvet summer night in August 1988, I walked into the Piazza

and painted the first of many watercolours of the floodlit façade of San Marco.

In March 1989, I returned to work on a larger version, this time in a bitterly cold spring that gave quite different colours. It was so dark I had difficulty in seeing what I was painting and had to memorise the colours in the pans in the paint box and hope that I had got it right. It was easier when the lights came on in the shops under the arcades, but my work finished abruptly the minute the shutters came down for the night.

Lit up against the deliciously painterly, inky March night sky, the façade of San Marco sits, compact beneath its domes, behind the soaring bulk of the bell-tower. The verve and breadth of the artist's brushwork has a real integrity that the comfort of a warm studio might on occasion not permit. Sitting in the Piazza on that cold night, Pamela has relied on her great energy to capture the sharply contrasting elements of the scene in the most effective and economical way that the resources of watercolour allowed her. The completeness of the image, all drawn and painted with the brush, is quite an achievement. However, her brave forays with her watercolour equipment into the places other artists may not attempt to reach could, and did, lead to problems:

On the most recent visit in September 1989, especially to prepare work for *Visions of Venice*, I arrived early at the Basilica on my very first day and waited patiently for the doors to open. I wanted to paint the interior as it is – crowded,

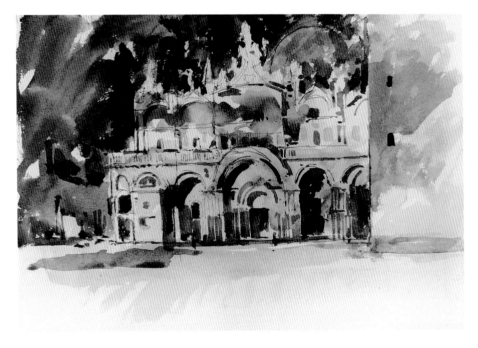

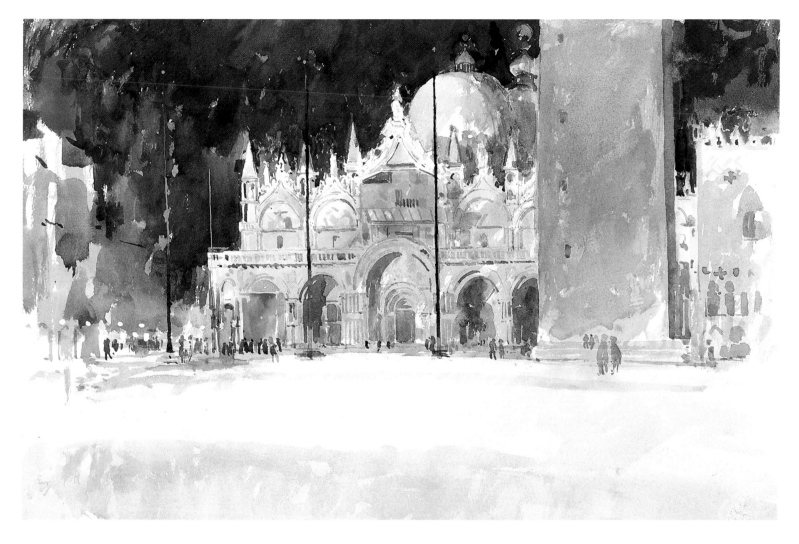

with an incessant shuffling stream of tourists.

Sitting well out of the mainstream at the foot of a pillar, I began a half-imperial watercolour, practising invisibility. Before fifteen minutes were up I was approached by two caretakers and achieved the rare distinction of being the first member of the RWS to be thrown out of St Mark's Cathedral.

I can clearly remember thinking 'Sickert didn't have this trouble' as I tried to explain that I was doing this for them, for Venice in Peril. I felt in far greater peril than Venice at that moment. I sat my ground and finished the painting, but realised this was no longer a place that was free to work in without special permission. All had changed.

It was however an ill wind. But for my summary ejection, I would never have been introduced to Lady Frances Clarke, co Vice-Chairman (with Lady Thorneycroft) of the Venice in Peril Fund, who was in Venice and not only made it possible for me to work in the Basilica, but also arranged for me to have permission to work in the Doge's Palace.

Pamela Kay
Sᴀɴ Mᴀʀᴄᴏ ʙʏ Nɪɢʜᴛ,
Sᴇᴘᴛᴇᴍʙᴇʀ
A larger, more finished work than the March view, the artist was clearly able to give more time to this superb watercolour, painted on a warm evening. The colours themselves are also warmer

*Loggia Foscari,
Palazzo Ducale, from the
Basilica San Marco*

ear and peered at me in eerie silence. Then they moved on to the next ancient monument.

Painting in Venice is like painting in no other place in the world.

One of the many fruits of the territorial rights provided on this visit was the watercolour looking towards the Campanile and the Piazza from the fifteenth-century Loggia Foscari of the Palazzo Ducale. The central position of this building over the centuries in the life of the Venetian state has helped to make it also one of the great architectural works of Italy. Ruskin, who devoted to it a chapter of *The Stones of Venice*, wrote:

Her understated efficiency and calm organisation turned a disastrous start into a prolific fortnight. It did not, however, entirely dispel my accompanying paranoia, which made me flinch whenever I was approached by anyone after that first morning.

Working in the Doge's Palace I was thirty minutes into the larger washes when a small lady clutching a clipboard materialised. My back is hard up against a pillar, there is nowhere to go. The clatter beside me is an electrician setting up lights. They're going to throw me out because I'm sitting just where they want to be!

'We're doing a documentary,' the clipboard lady says, 'would you mind if we filmed you?' 'Can I still get on with my work?' 'Of course.' I didn't actually believe her, so painted furiously in case she changed her mind. They blinded me with their lights, snapped clapperboards in my

The fact is, that the Ducal Palace was the great work of Venice at this period, itself the principal effort of her imagination, employing her best architects in its masonry, and her best painters in its decoration, for a long series of years; and we must receive it as a remarkable testimony to the influence which it possessed over the minds of those who saw it in its progress, that, while in the other cities of Italy every palace and church was rising in some original and daily more daring form, the majesty of this single building was able to give pause to the Gothic imagination in its full career; stayed the restlessness of innovation in an instant, and forbade the powers which had created it thenceforth to exert themselves in new directions, or endeavour to summon an image more attractive.

For Ruskin, one of the glories of the building was this loggia, which he painted and whose exquisite capitals he carefully recorded. In her painting, Pamela shows the fine arcade of the loggia and, with the aid of

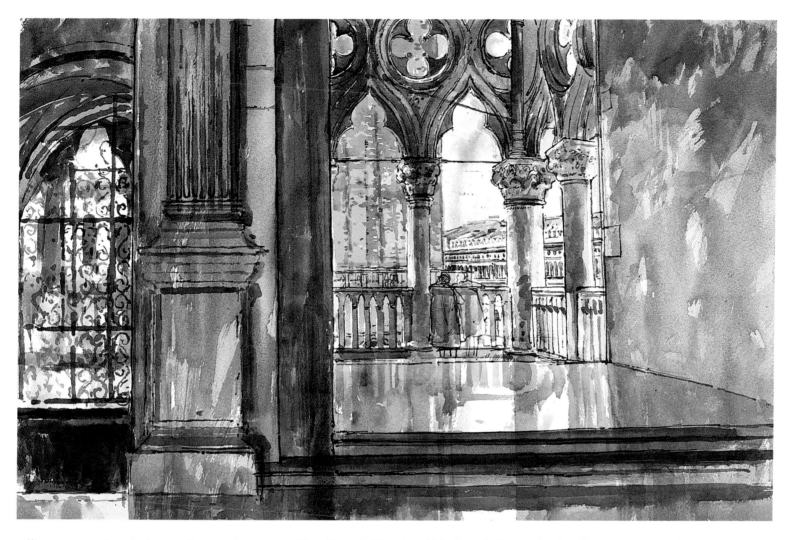

telling perspective, indicates its spaciousness with gloriously simple washes conveying the reflections in the shiny floor. As in the Basilica watercolour, she manages to combine vigorous brushwork with some economical, but effective, line (this time with the pen) to produce a complete and satisfying painting in front of the subject. It is an unusual vista, seen with a fresh eye and great clarity.

Born in Kent in 1939, Pamela Kay trained at Canterbury and at the Royal College of Art. For some years she worked as a textile designer, but now concentrates on her work in watercolour, gouache and oils, principally of still-lifes and interiors. She has had a number of one-woman exhibitions in London and elsewhere and her pictures are in many collections in Britain and abroad. In 1989 she illustrated the best-seller The Art of the Picnic. *Pamela, who lives near Margate, Kent, was elected an Associate of the RWS in 1983 and elevated to full Membership in 1986.*

Pamela Kay
THE LOGGIA, DOGE'S PALACE

PATRICK PROCKTOR

Patrick Procktor's Venice is one of the most delightful and original creations by a post war British artist. His vision is rich and intensely personal. The artist illuminates it in the following way:

I approach to Venice as to Arcady.

My friend Bryan Robertson recently commented my painting was 'all day and no night', that kindly dry and humorous wisdom 'common sense', which directs the arm of the artist to the world of dream.

Venice is in every moment iridescent, spectacular, but it also has pain, people. So this Arcady I paint is no never-never land, but a real stage for laughter, joy, love, solitude, *morbidezza*, and the moon.

Arcady, the classical paradise of innocence, *morbidezza*, conveying a soft mellowness that has no parallel in English – these words are the vocabulary of Patrick's vision of this city. The Venetian moon clearly holds so many artists in thrall. Staying in the city with a group of painters, I was continually conscious of how much discussed was light and its changeability. It was rather as though this particular cross section of the British people had surprisingly transplanted light for weather in their vocabulary. This feeling was reinforced when it took some two days of continual rain for anyone to start complaining about 'our typical weather'.

But the Italian moon is another ritual, as symbolic to the travelling British artist as the ruins of Rome, the vineyards of Chianti, or, indeed, the canals of Venice. Patrick Procktor's Venice of dreams is like a full Italian moon, the light which might be day. But even the early rising moon is a wondrous sight, as John Addington Symonds explained in *Sketches and Studies in Italy*, published in 1898:

There is the ever-recurring miracle of the full moon rising, before day is dead, behind San Giorgio, spreading a path of gold on the lagoon

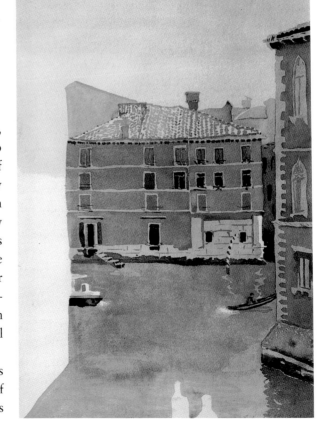

Right
Patrick Procktor
Early Morning, Venice

96

which black boats traverse with a glow-worm lamp upon their prow; ascending the cloudless sky and silvering the domes of the Salute; pouring vitreous sheen upon the red lights of the Piazzetta; flooding the Grand Canal and lifting the Rialto higher in ethereal whiteness...

In his watercolour of the island of San Giorgio Maggiore, taken from a viewpoint overlooking the San Marco *vaporetto* stop, the artist has used a rich build-up of elegantly simple washes to make a lyrical view of this famous subject. With characteristically limpid, but telling strokes of the brush, Patrick has overlaid the necessary detail in the most economical terms. There is about his technique a seeming innocence that belies his skills, a *morbidezza* that conceals any sense of struggle. This is a work of the contemplative beauty of a Chinese brush drawing, and undoubtedly some such influence exists.

Against the morning light, the lyrical silhouette of San Giorgio is easily depicted at that particularly satisfying angle to the Molo and Riva that John Julius Norwich has pointed out. In *Italian Hours*, Henry James wrote:

Straight across, before my windows, rose the great pink mass of San Giorgio Maggiore, which has for an ugly Palladian church a success beyond all reason. It is a success of position, of colour, of the immense detached Campanile, tipped with a tall gold angel. I know not whether it is because San Giorgio is so grandly conspicuous, with a great deal of worn, faded-looking brickwork; but for many persons the whole place has a kind of suffusion of rosiness.

The complex of buildings that comprise this

Benedictine monastery is generally considered to make it the most pleasing of the small islands of the Lagoon. The first church was founded in the eighth century and towards the end of the tenth the Isola dei Cipressi, as it was known, was granted to the Benedictines. After earthquake and much rebuilding the present refectory, cloister and church were built to the designs of Palladio from 1559 and the grand staircase and Library to those of Baladassare Longhena after 1641. Following suppression of the order in 1806, the monastery became a barracks and was allowed to fall into disrepair. It was restored in the 1950s as a memorial to his son Giorgio by Count Vittorio Cini. The campanile dates from the late eighteenth century and the twin lighthouses, to the left of the island in this watercolour, were built in the 1810s.

In this picture the overall qualities of the ensemble are personified in the simplest manner, for indeed this is a painting of light, shadow and colour,

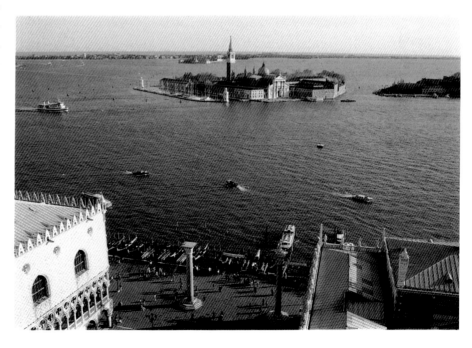

San Giorgio Maggiore from the Campanile San Marco

rather than of architectural detail. There is about this watercolour a sense of the glance taken from the privacy of a room with a view. A similar sense can be felt in the watercolour of a glimpse onto the Grand Canal on p96. This view over a chimney stack catches two river-craft disappearing out of the available vista, leaving the scene empty and almost anonymous. A stolen moment of experience is captured and rendered timeless in the artist's unfussy classical manner.

In these less-than-conventional compositions, Patrick reveals the sure local knowledge and appreciation of the character of the place that a long acquaintance with Venice can bring. In the San Giorgio watercolour in particular, the slightly off-beat viewpoint and the gorgeous handling of paint are in their understated manner, quite unique to the artist. When painting this work, one might imagine that in his ears the artist could hear the words of George Eliot in a letter sent to her sisters-in-law in 1880, the year of her death:

We have had nothing that we call heat yet – only a delicious sense of sun and a mild breeziness. But we seem to be almost the only persons in our hotel of the *forestière* species, and the Porter opines that everybody is now going to Switzerland...

...we live in deep retirement, partly in our rooms and partly in our gondola, never going to sit in the Piazza in the evening – the only place and time when there would be danger of greetings. – We have not yet had the longed-for solemnity of floating in the sunset glory of the lagoon. This we hope to do one evening by going to dine on the Lido and coming back at just the right moment...the most modest sunset sends a wondrous light over the watery scene, and every evening we see from our window the white church of S. Giorgio Maggiore and its red tower looking like ivory and coral. This place seems sometimes to me very toy-like with all its costly magnificence of old – as if the doges and grandees had been rich children who pleased themselves with making strange, pretty things on a mimic land in a safe, shallow lake.

Patrick's work explores this strange, toy-like city and brings it to life in some of the most poetic images of Venice ever painted.

Patrick Procktor
SAN GIORGIO, MORNING,
detail
This detail highlights the delightful texture of a series of fluid washes on rough paper

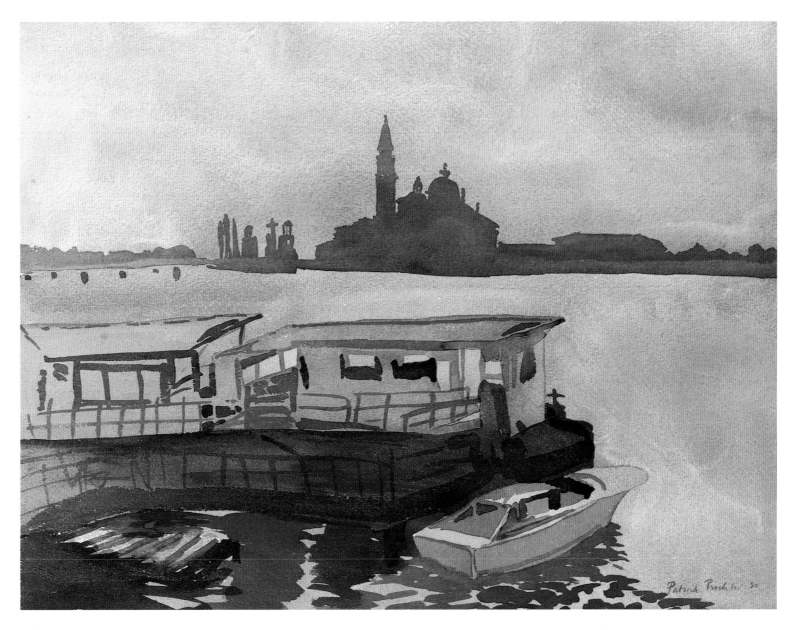

Patrick Procktor was born in 1936 and was trained at the Slade School of Art. Since 1962 he has been a full-time painter and was associated with the Pop Art movement in the early years of his career. Later he rediscovered watercolour, which he had not used since school, and now this is one of his principal mediums. He has had many one-man exhibitions in Britain and overseas. He has published books on his travels to Venice – notably One Window in Venice – and China, as well as illustrating other works, such as the Rime of the Ancient Mariner. Also a printmaker, Patrick was elected an Honorary Member of the Royal Watercolour Society in 1981. He lives in central London.

Patrick Procktor
SAN GIORGIO, MORNING

JACQUELINE RIZVI

Jacqueline Rizvi's Venice is an image of the city in-stilled in the artist by years of study of its arts, and of images and writings celebrating its beauty. She has been deeply inspired by the city by being there in spirit, rather than in person. Her inspiration is thus the Venice that, according to the French novelist Michel Tournier, is inculcated in the mind of every European. Those who travel there, he surmises, do so purely to recognise this mental picture – visiting Venice is like going to see the *Mona Lisa* in Paris, or *The Last Supper* in Milan.

The result is the monumental and beautiful watercolour *Venetian Apotheosis*, in which the Latin inscription carried by two goddesses translates as 'Both the light of Heaven and Painters praise together Venice, most serene Queen of Cities, beloved of the Muses'. Jacqueline Rizvi explains her mental picture of the city:

> We all have our vision of Venice. We have grown up with images of Venice in painting, in novels, in poetry. Venice is part of all of us. Rather than paint a topographical picture of Venice, I decided to paint a vision of Venice, the Venice in my mind.
>
> The subject of Venice, buildings reflected in water, arose logically out of the work I have been doing in St Katharine's Dock and by the Thames. I thought at first of doing a *capriccio* – Santa Maria della Salute in St Katharine's Dock? Ivory House with San Giorgio Maggiore? – but dis-missed the idea as irresponsible (though I think that Thames barges would look very well proc-

essing down the Grand Canal). Since the picture was to be a Venice of the imagination, there was no need to put any constraints on the subject at all, and it rapidly grew into something much more than an image of a city.

> For years I had attempted to form the idea of divine beings in the sky. I drew angels over the Thames and various annunciations. Figures in the sky above Venice became an apotheosis, something I had long wanted to paint, but did not know until now what form it should take. Some of my previous paintings have been indirect apotheoses. This seemed the ideal opportunity to

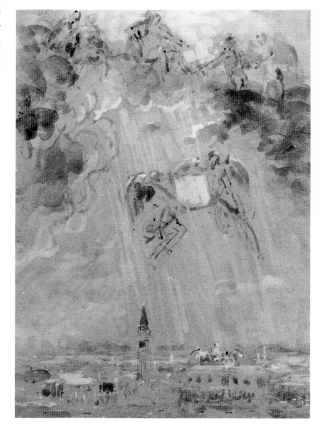

Right
Jacqueline Rizvi
Study for Venetian
Apotheosis
This is an initial monochrome study in watercolour and bodycolour on grey paper. At this stage the artist is beginning to formulate her concept of the composition

100

paint the subject directly, open-heartedly and joyously, with sumptuous colour and light. An operatic Venice which follows naturally from my recent work painting operatic productions. The form is essentially a Venetian one, so you could call the picture a painting about Venetian painting. It has become an apotheosis of both Venice and of painting in general.

The picture began with brief studies in the sketchbook of the figures flying upward with the inscription tablet, over some vaguely Venetian architecture. There followed two rapid preliminary studies; a monochrome, and a night piece with fireworks. Having established the idea, I drew from Turner, Canaletto, Guardi and others, taking a journey around the city, led by painters. I used photographs and transparencies as references too, to make several studies, on various papers, of the aspects I wanted.

I began to form the figure composition by doing a series of drawings from life. These needed to be *sotto in su*, so the models were posed on the table (blankets and cushions for clouds) and I drew seated on the floor below. I made far more drawings than the picture eventually required, to feel my way towards the final composition. From the drawings I did a large, rough and disappointingly unattractive working drawing (not as large as the final picture was to be), followed by a painted study, to work out the colour and tone balance. This is on grey Japanese paper, as is the final painting.

The diligence with which Jacqueline undertook this work was extraordinary for its thoroughness and inventiveness. The great number of figure studies she accumulated could have emanated from the studio

Jacqueline Rizvi
FIGURE STUDY FOR
VENETIAN APOTHEOSIS
One of the many preliminary drawings for the painting. Here the artist's daughter Sophie poses as a goddess

of a Renaissance master. Their use is a rare part of a painter's working practice today and is being consciously revived by this artist. Only once all the necessary information had been distilled into the large colour study could the construction of the final work begin. The finished watercolour, although on a vast scale, is painted with the artist's enviable delicacy of touch. Over a broadly painted foundation, she worked with brushes small for the scale of the work – the largest being a No 10 – building up the tonal and colouristic relationships by gradually working away from the middle tone of the paper towards dark and towards light. After weeks of painstaking work the glorious apotheosis emerged in its finished form:

The allegory is generalised. The personification of Venice welcomes artists to the heavenly regions. It was a problem whether to make the artists semi-nude or clothed portraits; contemporary dress would look self-conscious and silly. I decided to make them semi-nude, for the sake of tone and colour balance. Fame nose-dives through the higher clouds, with laurel wreath and trumpet; on the left another goddess presents a wreath and a male trumpeter stands among the clouds (the pose derives from a trumpeter I saw playing in a concert of eighteenth-century music at the National Gallery). Venice is attended by

young divinities, who could be taken to be the hours, the civilised pursuits or muses. Two young goddesses fly upward in a great beam of light, carrying an inscription in praise of Venice and art. All this activity takes place in, and enhances natural light conditions. Many drawings of cloudscapes and waterscapes underlie the composition, so the painting combines artifice and naturalistic observation.

Was it a foolhardy idea? It may be so, but it is something I felt impelled to do. The subject draws together many threads in my work – some of which go back a very long way. A beautiful city by water; the allegorical subject; light effects; theatrical and operatic invention and movement.

Jacqueline Rizvi
LARGE COLOUR STUDY FOR
VENETIAN APOTHEOSIS

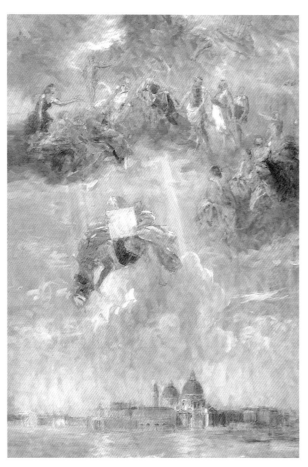

If Jacqueline's city is the Venice of the imagination, it is also the Venice of the High Renaissance and the years of Empire. In *Modern Painters*, Volume V, Ruskin described this Venice through the eyes of Giorgione:

A city of marble, did I say? nay, rather a golden city, paved with emeralds. For truly, every pinnacle and turret glanced or glowed, overlaid with gold, or bossed with jasper...A wonderful piece of world. Rather, itself a world. It lay along the face of the waters, no larger, as its captains saw it from their masts at evening, than a bar of sunset that could not pass away; but for its power, it must have seemed to them as if they were sailing in the expanse of heaven, and this a great planet, whose orient edge widened through ether, a world from which all ignoble care and petty thoughts were banished, with all the common and poor elements of life. No foulness, nor tumult, in those tremulous streets, that filled or fell beneath the moon; but rippled music of majestic change or thrilling silence.

Jacqueline Rizvi was born in Yorkshire in 1944 and studied at the Chelsea School of Art. She paints full time and her watercolours have been seen in one-man and mixed exhibitions in London and around Britain, as well as in Europe, the USA and Japan. Her work is in many private and several corporate collections and her commissions have included two from London Underground. Jacqueline, who now lives in North London, was elected an Associate of the Royal Watercolour Society in 1983 and was promoted to full Membership in 1986.

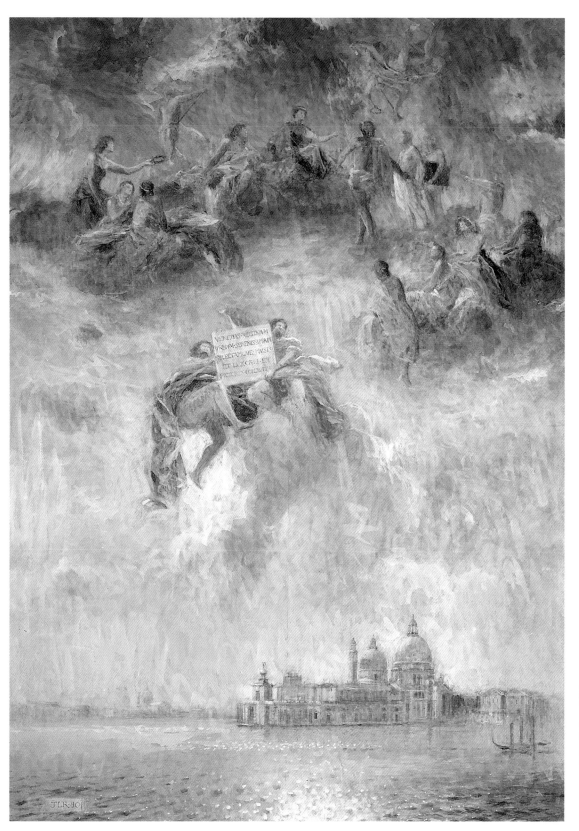

Jacqueline Rizvi
VENETIAN APOTHEOSIS
At 55"x 40"
this is the largest watercolour
commissioned for
Visions of Venice

HANS SCHWARZ

Hans Schwarz is an artist of intuitive and individual painterly gifts who claims not to be in total control of whatever process brings his paintings to their result. Nonetheless, it is evident that the intensely coloured watercolours he produces are born of a deep understanding of his craft. He likes to paint in hot bright surroundings, and the work realised under the Venetian sun typically has heightened expressionistic colour values that surely echo his central European heritage.

This is how Hans Schwarz explains his experience of painting in the city:

Paradoxes abound in Venice. A city without streets or cars, built over a thousand years – yet of a piece; rising from the sea, sinking back inch by inch; Eastern and Western at the same time; every stone documented and delineated, but round every corner there is a discovery to be made; known from paintings – the best and the worst – and photographs, but fresh to the first-time visitor; jostling tourist hordes are yards from deserted lanes.

I painted there for two weeks, working hard and limiting sight-seeing and museum visits to a minimum. Most of my paintings were done within a few hundred yards of where we stayed – for convenience – I paint fairly large and I don't like having to carry my equipment any distance. But I have a more important reason. I paint best if the subject is familiar, if I have walked around it, have got to know it well. So, many of the paintings are of views within a few minutes walk

of our hotel – Salute, Zattere, Dogana and the canal outside the hotel. In Venice, which is as full of quotations as Shakespeare, I particularly had to digest and make mine a spot before painting it.

On his travels around the city, however, Hans was photographed in a *traghetto* – the twin-oared gondolas which ferry passengers across the Grand Canal – and this provided the idea for a painting. This self-portrait is a vivid example of the intensity of his colours and the breadth of his brushwork, although there is here a certain orderly quality to the brushstrokes that painting before the subject does not always induce in the artist. The appeal of the painting and the wit of its composition are a lesson to those who copy from photographs. The camera has been employed creatively, for without the snapshot the possibilities of the scene would probably not have been realised. Of course, this is not a copy – in fact, the painting has ended up being very different from the photograph. It is the idea and the information the snapshot provided, rather than its precise visual appearance, that were of use to the artist.

More typically, Hans works directly before the subject, using no photographic reference at all. The watercolour of a curious jetty, interrupting the view from beside the Dogana di Mare, over the Giudecca Canal to the Church of the Redentore, is a magnificent example of this approach. The photograph of the scene, taken on a later, much duller occasion, shows that the artist has been true enough to the layout of the scene, except for deciding to omit the mast protruding above the wooden hut and the jetty in the middle

104

distance. However, it is the glorious jangling brush-
work with which the artist conveys the brilliant reflec-
tions of light on the open waters of the canal that is the
real subject of the piece.

The Punta della Dogana – the spit of land
facing San Giorgio – provides vast views over the
Lagoon. In *Sketches and Studies in Italy*, John Adding-
ton Symonds recalled standing here as being '...out at
sea all alone, between the Canalozzo and the Giudecca.
A moist wind ruffles the water and cools our forehead'.
That was at night, but in Hans Schwarz's picture the
choppy waters throw off a myriad of colourful reflec-
tions. Working at speed with bristle brushes, the artist
has captured this light effect in the one and three
quarter hours he was on the spot. Then, back in
London, he spent rather longer reworking the paint-
ing, '...not changing it fundamentally, but balancing
and enriching it.'

Hans describes here how he approached the
subject:

Next to the custom house there was this humble
shack on stilts, a gangway connecting it to the
shore; purpose unknown, one of Venice's minor
mysteries. I liked this stumpy lump with its little
pitched roof, stalking into the Lagoon. It was
also a relief to find something to paint in Venice
which could not have been painted by Canaletto
or Turner. Indeed I quite likely was the first
painter to make it the centre of a picture. It
stands a few minutes walk from our hotel. I
passed and re-passed it every day on my pre-
breakfast stroll. It became familiar.

In early September the first few days were
misty and oppressively hot. I'm not Turner, mist
doesn't turn me on. Then the weather changed.
After one day's drizzle it became sparklingly clear

Hans Schwarz
Self-portrait in a
Traghetto

with bright sunshine. On a breezy late afternoon, facing the sun, staccato sparks coming off the ruffled water, I painted the picture. I like *contre-jour* subjects. I revel in the colour – or the colour I imagine – of objects seen against the light (a German tourist watching me paint said 'he's got the colours all wrong, but it looks right'). These areas of deep colour allow me to use strong colour in the relatively light areas.

The special light Venice is supposed to possess is wasted on me. I do need the stimulus of something in front of me and it must be something which stimulates and absorbs me, and I do look at colour in nature. But that is only the starting point. Then I take off into what are for me unpredictable directions, sometimes reversing colours (I have painted red trees and green faces), at times bending all colours in one direction – towards green, blue or violet. I have painted pictures exclusively in complementary colours –

for instance every object became either red or green.

I can't remember what was in my mind at the time, but I am sure that as always it was a struggle with a lot of heart-searching and changes of mind (things which I hope don't show in my finished work). Ultimately I must have felt that contrasting, clashing colours best represent the kaleidoscopic sparkle of disturbed water seen against the light.

Any illusion of distance is far less important to me than the all-over density and structure within the painting's rectangle. Every square inch of a painting is of equal importance to me. The shape of a cloud matters as much as the shape of a rose or a nose *and* I want all the shapes to fit together like risen buns in a bakery tray.

In spite of liberties I take, in spite of distortions and seemingly arbitrary colour changes, my painting are 'real' to me – and I hope to others. When I now look at these paintings, done nearly two years ago, they are more than a reminder of a magic town; they are Venice.

The Redentore from Fondamenta delle Zattere al Saloni

Born in Vienna in 1922, Hans Schwarz trained there at the art school, before fleeing the Nazis and arriving in Britain, where he attended the Birmingham College of Art. He works in a wide variety of mediums and has had many one-man and group exhibitions. His pictures are in the collections of a number of municipal galleries, as well as in the National Maritime Museum and the National Portrait Gallery, which has commissioned work. Hans, who lives in London and Somerset, has also written on the practice of painting. He was elected ARWS in 1982 and a full Member of the Society in 1983.

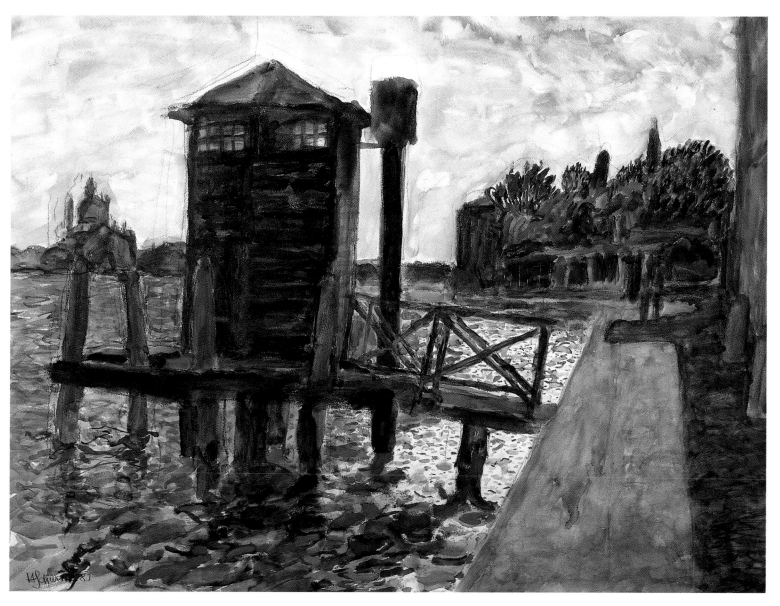

Hans Schwarz
SUN ON THE WATER, VENICE

LORD THORNEYCROFT

Lord Thorneycroft is an artist for whom the time to be able to concentrate on painting came fairly late in life. In the last few years he has increasingly chosen to hand on offices of state and international business. Accordingly, he has devoted more of his attention to the practice of watercolour. This is not to say, however, that he was not already an established practitioner. In fact, Lord Thorneycroft's position in the annals of British watercolour is stronger even than it might at first seem. He continues, in the finest manner, the art of the amateur.

Described by Lord Clark as 'a painter who happens to be a VIP', Lord Thorneycroft's enviable ability with the watercolour brush enables him to record with consummate alacrity of technique the by-ways of Venice. His is an inheritance of amateurs, whose privileged education included the inculcation of the practice of watercolour by professionals from Peter De Wint to, in this case, Vivian Pitchforth.

Lord Thorneycroft has a particular acquaintance with Venice, shared with his Italian wife, who is a Vice-Chairman of the Venice in Peril Fund. His experience of Venice is probably greater than that of any other of the commissioned artists. His advice to the amateur draughtsman or watercolourist who wishes to record the city is, I suspect, incomparably helpful:

> There are many beautiful paintings of Venice, some of the greatest being by the Venetians themselves, others by masters of the Art from other countries and, as this book shows, the tradition still continues.
>
> The sketches illustrated here are in a humbler tradition. There is no more delightful occupation than wandering through Venice with a pen or pencil, a notebook and a very few colours, and seeking to record one or two glimpses of that lovely city.
>
> A sketch is different from a painting. It is drawn for the pleasure of the sketcher rather than anything else. There is no intention to exhibit it. It generally remains in the sketchbook. It is

Lord Thorneycroft
CAMPO SAN ANGELO

certainly an ideal occupation for the amateur, but has been used also by the great masters – Edward Lear for example made little thumb-nail sketches to decide on the general composition before starting on the larger work. Some of these are still to be seen in the corner of his watercolours. Some are just sketches, and sketches by some of the great masters such as Guardi rank among the most delightful representations of the Venetian scene.

I commend the technique to anyone prepared to carry the minimum equipment needed when they set out on their travels. It is a memento of

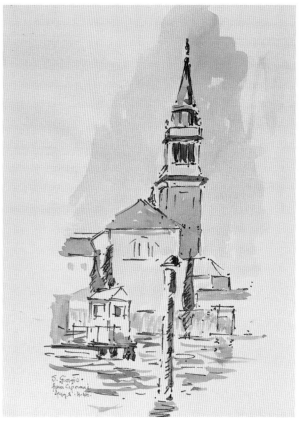

Lord Thorneycroft
SAN GIORGIO FROM CIPRIANI
This study of a view from the famous hotel is one of the artist's many spontaneous sketchbook drawings of Venice in pen and sepia wash

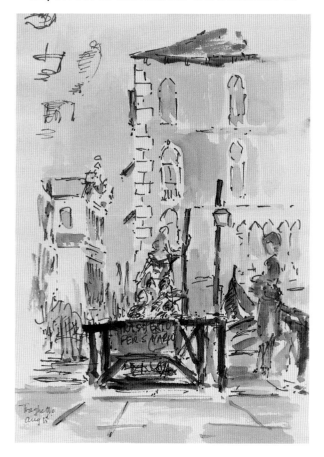

what they see. It is a carefree kind of painting. It is a sort of diary of a happy day – at its best it may even produce a kind of beauty of its own.

Amateurs are, I think, well advised to try to sketch and paint details rather than try to capture the large and imposing scenes that strike the eye at almost every corner. Try a doorway in a side canal before attempting the Salute! Above all look hard for the reflections. The shapes and colours of Venice are gently reflected in the waters upon which the city stands. To sit alone with a sketchbook and a few paints and watch all this is an occupation in which a man will never tire.

Left
Lord Thorneycroft
TRAGHETTO

109

Santa Maria della Salute from Rio Terra dei Catecumeni

The principal watercolour reproduced here is a view of the less glamorous side of Santa Maria della Salute, seen from the corner of the Rio Terra dei Catecumeni and the Calle Nuova, north of the Zattere. Visiting the site in November 1989, a year or so after this watercolour was painted, it was quite magical how the sun returned to the streets and, in an instant, the atmosphere of the artist's warm and busy scene was revived. No longer were café tables in the street, but the accuracy of this amateur's drawing was excellent enough for the exact vantage point to be located, as the photograph shows. The scene is described with brief and delightful washes of the brush, which is confidently handled to create a most enjoyable image. The composition is reinforced with descriptive, but subtle, pen lines.

Such lines are more in evidence in Lord Thorneycroft's sketchbook studies in which he concentrates on the minutiae of Venetian architectural detail. These ink and wash drawings are reminiscent of sketches and etchings made by great students of Venice from the past, from Prout to Whistler. Despite his amateur status, admitted here because he seems to prefer it, the view of the Salute is the product of a lifetime – however part-time – of observation and experience.

In Lord Thorneycroft's watercolour we see the great dome and the side-towers which presage the ambulatory of the Salute. This back view of the church may not be its most glamorous, but it does reveal this extraordinary piece of Baroque architecture at its simplest and, some might say, its most architecturally pure state. The Salute is the masterpiece of Longhena and was built by a decree of the senate of Venice of 1630, in thanksgiving for delivery from a plague that is thought to have killed fifty thousand people.

The major monument of the district of Dorsoduro, the Salute is the perfect foil for the architectural complex of San Marco and represents its twin portal to Venice from the sea. Finished after the architect's death in the 1680s, the church became the focus of an annual pilgrimage of thanksgiving, which is still celebrated in November. In *Life on the Lagoons*, published in 1884, Horatio Brown described the festival as it was then held:

On three occasions only in the year are pontoon bridges thrown across the Grand Canal – on the Day of St Anthony, the Day of the Redentore, and this Festival of the Salute... On the Day of the Salute there are two bridges – one for going and one for coming. The crowds that pass backwards and forwards all day are very large, for the inhabitants of Venice, even those who are ordinarily indifferent to the Mass, feel bound to visit the church upon this festival.

Santa Maria della Salute remains a church of the Venetian people. Perhaps it represents to them what St Paul's does to the people of London. It is only fitting therefore that the featured watercolour of such a notable democrat as Lord Thorneycroft should be this delightful account of the Salute.

Peter, Lord Thorneycroft, was born in Staffordshire in 1909 and was commissioned in the Royal Artillery in 1930. He was later called to the Bar and was first elected to Parliament in 1938. He has held several of the great offices of State, including those of Chancellor of the Exchequer and Secretary for Defence, and was later Chairman of the Conservative Party as well as a prominent businessman. He studied at Chelsea School of Art and has written a popular book on watercolour painting, The Amateur. *Lord Thorneycroft was elected an Honorary Member of the Royal Watercolour Society in 1982 and was Chairman and then President of the Friends of the RWS from 1984 to 1989. He became a Companion of Honour in 1980.*

Lord Thorneycroft
Rio Terra dei Catecumeni

JOAN VERNON–CRYER

In her watercolours Joan Vernon-Cryer has often revealed to us aspects of the Venetian scene that have either been off the beaten track of most painters or are untypical views of familiar subjects. *Reflections in Glass and Mirrors* is no exception. One of the great pleasures of walking in Venice is to allow one's eyes to be indulged by the beautifully laid-out windows of the many shopping *calli*. Window shopping is such a civilised exercise in this city, a natural adjunct of moving from A to B, that no artificially created plaza or pedestrianised zone is likely to be able to match.

The patterns of the small, often crammed windows soon become familiar: the *drogheria* displaying the full range of Italian foodstuffs; the window displaying carnival masks; the shop selling every conceivable pattern of marbled paper, decorating a bewildering variety of objects; the sweet selections of the *confetteria* and *pasticceria*; the glint of jewellery and coloured glass; the gloomy interior with antiques and paintings; tastefully displayed clothes and leather goods. Less common and often a discreet, but still recognisable, part of the Venetian scene is the window display of the craftsman frame-carver. One eye-catching example nestles between a bridge crossing the Rio di San Barnaba and the church itself. Joan describes what led her to create her image of this decorous window:

Recollections of Venice inevitably bring to mind her reflection in water – the great palazzi reversed and quivering in the canals – and unfortunately nowadays agitated to a point resulting in frustration for the beholder. Then, one day, gazing into the window of an antique shop in the Campo San Barnaba, I realised how many windows reflected Venice too – churches and homes of the Venetians less grand than the palazzi! I also became engrossed with the contents of the windows and I have made many paintings of these typically Venetian artifacts – glass, lace, ceramics – and always incorporating reflections of the buildings in the vicinity.

Reflections in Glass and Mirrors took me several visits to complete (the contents of this window change little from year to year!). After a preliminary sketch I took snapshots with my small camera on several subsequent visits – I found these crafts-people invariably pleased to be sketched or photographed – and eventually in my studio designed the final image of the window, which you now see in the watercolour.

Taking a break from his work for a cigarette and a chat, the frame-carver of San Barnaba appeared oblivious to being photographed as he showed off a piece of fabric to a friend. He is one of the many craftsmen of Venice, most of whom work in less visible surroundings – often in a quiet *calle* one will pass an open door and glimpse a hive of activity. In *Pictures from Italy*, published in 1846, Charles Dickens mentioned 'Floating down narrow lanes, where carpenters, at work with plane and chisel in their shops, tossed the light shaving straight upon the water, where it lay like weed, or ebbed away before me in a tangled heap'.

For the moment, our man was not throwing any shavings. His November window-display had, however, undergone a little rearrangement since Joan recorded the scene, but was nevertheless familiar from

Far left and left
*Campo San Barnaba,
frame-carver's shop*

her carefully descriptive watercolour. So was the reflection of the buildings on the opposite side of the canal. Particularly pleasing was the fascinating array of angled planes that the elaborately shaped and framed mirrors created.

What the artist has discovered and depicted is a fractured, but wonderfully decorative, pictorial space. She has faithfully transcribed what is before her – or rather, what she has chosen to place herself before – and has brought out the abstract qualities of form, line and tone that are latent in the scene. The result could almost be described as a cubist subject drawn with a rococo line! As with the analytical paintings of Picasso and Braque, this work's monochromatic nature is an aid to our reading and understanding of the complex and multi-layered arrangement of interlocking planes.

The extensive preparation which lies behind this watercolour is evident if one dwells a while on the image. This is not the capturing of a fleeting moment – indeed, the display must have changed a little between Joan's visits – rather it is a formal arrangement of the various elements of the subject, composed in the most satisfying way the artist could find. *Reflections in Glass and Mirrors* is a deeply considered, painstakingly forged image of timeless quality. The artist describes how she goes about preparing the exhibition watercolour:

I design my finished paintings in my studio. I use several different papers, choosing each time a paper to suit the general effect I hope to convey. I mostly use Whatman (old) or Saunders, Ingres, or old Fabriano if I need a brilliant white – for I leave the paper to furnish the highlights – I rarely use white watercolour. I sketch the design with a 3H pencil, which is not visible when the painting is completed. I do not like to use the same mounting or framing for every picture, but try to suit these to each particular painting – which does not, I suppose, lead to easy hanging in an exhibition – or indeed to a quick output of work! However, I prefer to use these tactics and to regard each new painting as an individual effort.

The care involved in the selection of materials is characteristic of the artist, whose decorative sense is especially clear in her Venetian shop windows. In *Masks for the Carnival* she paints the riot of colour of a mask shop at carnival time:

I have made several visits in February, to observe the Venice carnival, when shop windows are gay and sometimes a little sinister, with carnival masks, fans, very paintable feather boas and shining garments to tempt the shopper (everyone

must dress up, day and night, for a whole week). Reflected in the windows is a motley crowd of passers-by. Inside the shops, mask-makers demonstrate their skills and will make a mask to one's own specification!

Less deliberately designed than the more formal frame-carver's window, this watercolour is treated by the artist as a freely patterned array of brightly coloured shapes, strewn across the flat picture plane that the window represents. Less analytical and with few ambiguous reflections, it does nevertheless invite the viewer beyond the masks staring out of the dominant picture plane, into the bustle of human activity within the shop. It is a joyful, yet perhaps a slightly menacing painting – a befitting vision of Venice.

Joan Vernon-Cryer
REFLECTIONS IN GLASS AND
MIRRORS, VENICE

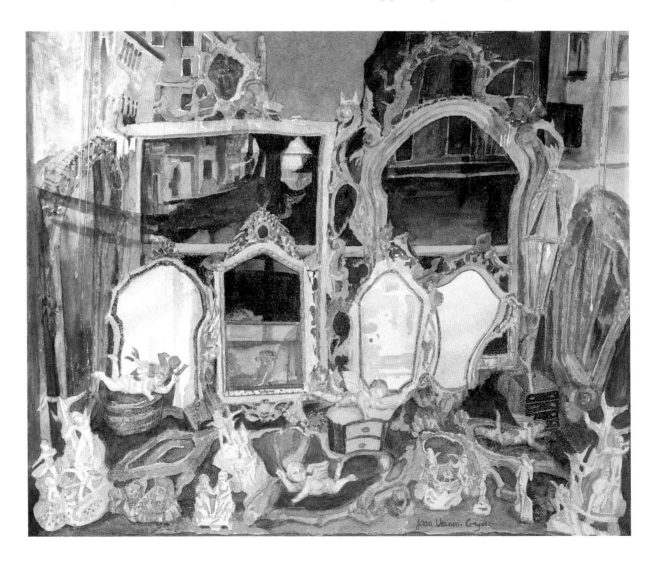

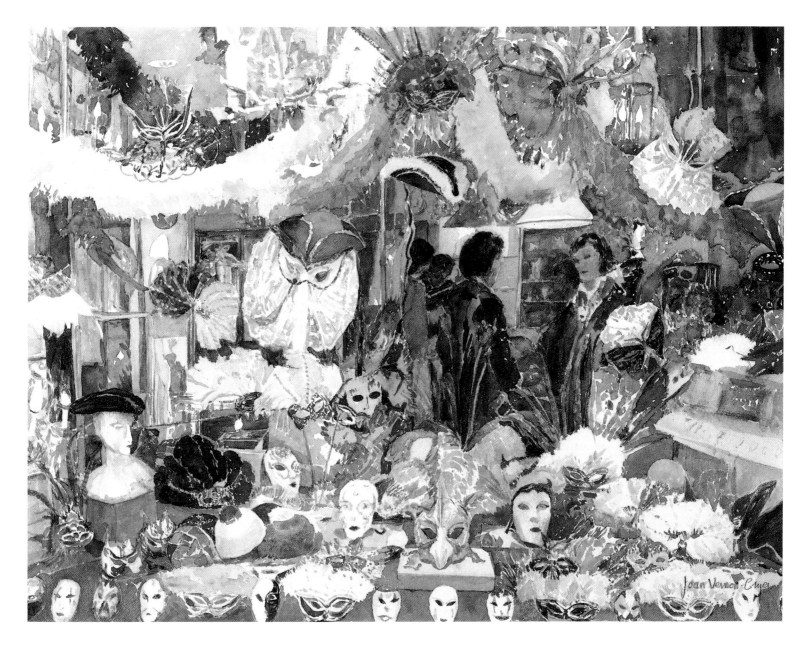

Born in Blackburn in 1911, Joan Vernon-Cryer trained there in the Art Department of the Technical College and then at the Royal College of Art, obtaining her diploma in painting. She went on to work as an art teacher in London schools for physically handicapped children and received her art teacher's diploma. She has exhibited her watercolours of landscape, architec- tural and figure subjects in many exhibitions, includ- ing those of the Royal Academy. Her extensive travels are reflected in her subject matter, notably of Venice. Joan lives in Kingston-upon-Thames, Surrey. Having been elected an ARWS in 1970, she was made a full Member in 1976.

Joan Vernon-Cryer
MASKS FOR THE
CARNIVAL, VENICE

JENNY WHEATLEY

Patterns of decay in Rio della Madonna dell'Orto.
A characteristic Venetian water-line

As an adventurous traveller, Jenny Wheatley has in her brief career so far built up a portfolio of subject matter for her watercolours as varied as a travel brochure. She is not, however, only a collector of places. She has also accumulated an exotic array of artefacts from around the world, which regularly feature in her inimitable still-lifes. The heightened palette of these works, sometimes using fabric dyes, also surely reflects her interest in the native art and design of peoples from Asia to the South Pacific.

In Venice, Jenny is also found to be exploring further afield than some, and the two watercolours reproduced here were made in the relatively unfrequented northern district of Cannaregio. She clearly loves Venice for the sense of discovery each new turning engenders:

On each occasion that I have visited Venice I have expected the islands to become a little more ordinary – a little less of an overloaded visual surprise – but the effect seems to work in reverse and on each trip it seems a little more extraordinary that such an expansive mixture of elegant and anachronistic façades and waterways should exist. As one ventures further and further into the mazes of alleys that join tiny squares or end abruptly as they meet an unexpected, narrow canal, the echoes of footsteps seem to blend together with past and future and one feels an insignificant outsider under tall façades, with their ornate windows and geranium-stuffed balconies.

My over-riding fascination was initially, and remains, the flatness of the façades and their over-ornate splendour, enhanced by their state of watery decay. The controlled arbitrariness of watercolour stains that creep across flat planes, linking one building's façade with another's, seem the best way to express the Venetian glow of coloured plaster under the strain of rising canal-water, seeping higher and higher through the noble exteriors.

When the watercolour paper has been sufficiently covered in multiple stains and coloured washes, the process of incorporating and adding the decorative embellishment takes over. At this stage it is important to try to keep the paper at the right dampness to be able to place soft, spreading decoration in some areas and harder, more precise pattern in others – always remain-

ing aware of the effect of colour upon colour and tone upon tone.

On my first excursion to Venice I tried to look solely at the very flatness of each façade. On subsequent visits I have become more interested in trying to create something of a stage-set – still exaggerating the flatness of the buildings, but slotting the exteriors as stage-sets to create a flat space – façades and patterns dancing together and vying for importance, as the lack of space in Venice itself dictates.

To come anywhere near achieving the goals that I set myself in this very special, unreal city of façades will be a struggle that is unlikely ever to reach a satisfactory conclusion, but is exciting and enjoyable in the trying.

Both the watercolours shown here well illustrate Jenny Wheatley's aims and are ample evidence that even if she has yet to meet her own demanding standards, hers are among the most appealing of contemporary Venetian paintings.

In the watercolour of the Pescaria, where the Ponte Guglie crosses the Canale di Cannaregio, the differently angled walls are flattened onto one picture plane of melting colours. On top of this the array of windows and other architectural furniture have been applied with the brush. The coming together of these walls clearly echoes the stage-set, and one might recall the stage designs of John Piper, who has also, in much of his easel work, applied architectural detail over washes.

This flatness of façades to which Jenny refers – the remaining patches of stucco creating arbitrary patterns with the exposed brickwork – is a pervading factor of the Venetian scene. Restoration of canal-lapped walls, although it is undertaken, is clearly

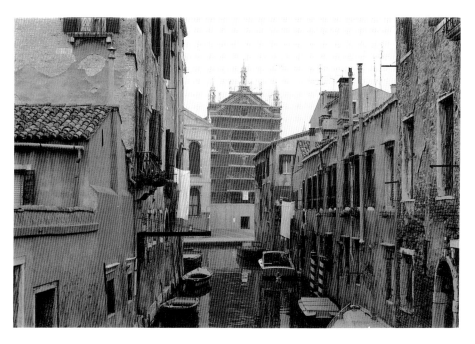

Madonna dell'Orto from Ponte Guglie

awkward and expensive. The result for this visiting artist is a picture of evocative decay of which she takes full advantage. This is illustrated by comparing the watercolour of the Church of Madonna dell'Orto with a photograph of the scene.

The view is taken from the Ponte Brazzo, looking along the Rio Braso towards the western façade of the church. As the appearance of scaffolding in the photograph indicates, new restoration work on the church began in the summer months of 1989, a few weeks after the painting was made. In the top-left corner of the watercolour an example can be seen of how the artist has allowed her partially controlled washes to describe the patches of plaster and brick.

This admirable watercolour shows how far the medium may be pushed within boundaries of topographical convention. Part of the secret in this case is to portray recognisable details with an exactitude unnecessary in more abstract areas of the scene; part is

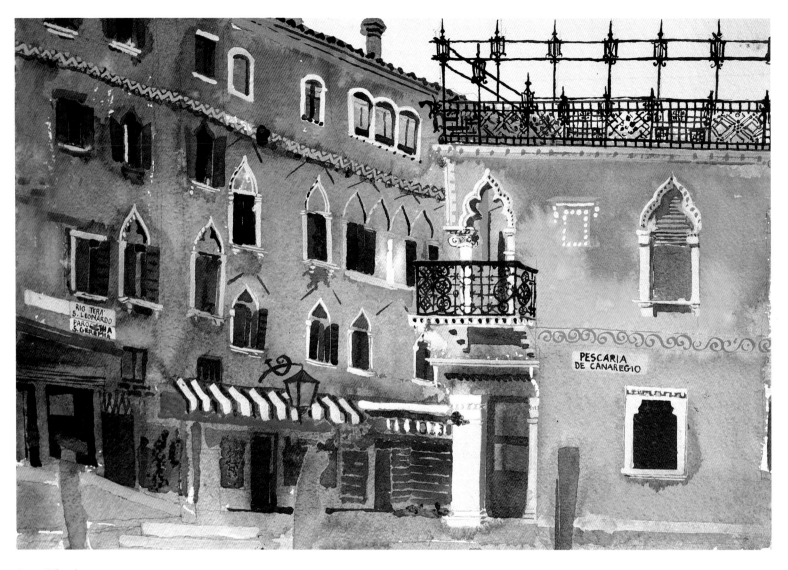

Jenny Wheatley
PESCARIA DI CANNAREGIO

the artist's ability to convey in economically handled, yet rich washes, the warm tones and colours that are so very Venetian. Jenny has also been selective about the elements of the scene she has included. Having set her pitch some hundred yards from the church, she has chosen a narrow perspective, which suits her requirements and arranges the composition pleasingly.

Madonna dell'Orto was built in the early fifteenth century and is considered one of the finest of Venetian Gothic churches. Its charming brick façade of about 1462 is transitional with the Renaissance style and includes some fine sculpture, including early work of Antonio Rizzo. Madonna dell'Orto was Tintoretto's local church and it contains many of his paintings. It suffered badly in the floods of 1966 and was the first church to be restored under the auspices of the Italian Art and Archives Rescue Fund, under the Chairmanship of Sir Ashley Clarke. This body was the precursor of the Venice in Peril Fund, which – now under the Presidency of Sir Ashley and the Chairmanship of Lord Norwich – continues its task of restoring important buildings in the city.

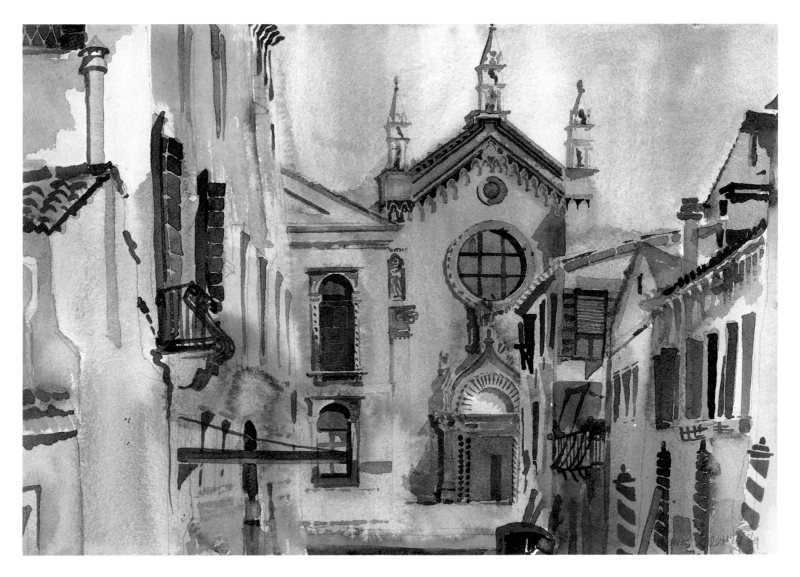

Jenny Wheatley was born in 1959 and trained at the West Surrey College of Art and Design. She has travelled extensively in Europe, Asia and the Pacific and her work on paper or canvas reflects and depicts many of these places. She often works with fabric dyes for their brilliance and typically paints still-lifes and landscapes. Jenny, who lives in Kent, was made an Associate of the Royal Watercolour Society in 1984 and was then elected a full Member in 1987.

Jenny Wheatley
MADONNA DELL'ORTO

MICHAEL WHITTLESEA

Stay for any length of time in Venice and one soon comes to recognise the Ponte di Rialto as one of the principal hubs of the city's life. With the exception of the temporary modern structure by the Accademia, it is the only bridge over the Grand Canal in the centre of Venice. The present stone bridge was built on the site of a succession of wooden constructions by Andrea da Ponte between 1588 and 1591.

When the seventeenth-century diarist John Evelyn visited Venice, he seems to have been most impressed by the feat of engineering, which at that time the Rialto remained. It was 'celebrated for passing over the *grand Canale* with one onely Arch...built of good Marble, & having on it, besides many pretty shops, three stately & ample passages for people, the 2 outmost nobly balustr'd with the same stone, a piece of Architecture to be admired'.

The Rialto had long been famous in Britain as a centre of trade, and is described as such throughout Shakespeare's *The Merchant of Venice*, where Shylock holds an impressive position there. Mrs Piozzi was not quite so impressed by the bridge's shops when describing them in *A Journey Through France, Italy and Germany*, of 1789:

> But it is almost time to talk of the Rialto, said to be the finest single arch in Europe, and I suppose it is so – very beautiful, too, when looked on from the water, but so dirtily kept and deformed with mean shops, that, passing over it, disgust gets the better of every other sensation.

Michael Whittlesea's first visit to Venice was presumably far more savoury. Here he describes the

circumstances that led him to making his most painterly and attractive watercolour of the steps and shops leading over the Rialto, from the south side:

> I arrived in Venice for the first time in early January. My first view of the city, as it emerged from the icy mist, was exactly like I thought it would be. No disappointment there.

Right
*Ponte di Rialto from
Ruga degli Orefici*

From the Lagoon, Venice looks much bigger than it really is. The buildings do appear to be 'bathed in light'. You are made aware of how the quality of light is so important when you look at Venice.

In contrast, inside the city, the light produces dramatic darks and lights. You walk out of very dark shadows into well lit courtyards.

I decided early on that I wouldn't settle down to draw, but would walk, discover and enjoy the city. It seemed a pointless exercise to draw views that had been painted and written about, with various degrees of success, for centuries. I suppose I was in sympathy with the school of thought which said that an original and personal view of Venice is impossible.

Venice is a baffling city and it was very easy to lose all sense of direction. At first it was disturbing, but then I found myself looking forward to finding out what was around the next corner.

Walking through the market stalls leading up to the Rialto Bridge from the Ruga dei Orefici, wide steps lead up and over the bridge. Stalls sell everything from fruit to lace. It was crowded with people. The winter sun cast strong shadows. It doesn't look like a bridge from the bottom of the steps. There is something theatrical about the steps. A huge stage set, with players moving up and down on it. It was a view of Venice I had never seen before.

For this reason I decided to draw after all, or at least to make notes and sketches. I wanted to put down just what it was that had attracted me. It was cold and crowded, notes and sketches had to be done quickly, and as usual I tried not to attract attention. I revisited the area a few days later to see if there was anything else I should

Michael Whittlesea
STUDY FOR RIALTO STEPS
This is the first study with colour notes, in which the artist lays out his first ideas for the composition

draw or photograph before leaving.

Returning to London, the material brought back from Venice helped to produce several paintings in both watercolour and oil. The drawing and structure of the buildings and the bridge were carefully drawn; a feeling of solidity. Then populated.

The photograph, taken in November 1989, serves to emphasise that the people are using these steps, not only for passage down into the extensive and fascinating Rialto markets, which are the main source for fruit, meat, fish and vegetables in this supermarketless city, but also as a convenient meeting point. In *Italian Hours* Henry James described how the Rialto markets are

...a fine place to study Venetian types. The produce of the islands is discharged there, and the fishmongers announce their presence. All one's senses indeed are vigorously attacked; the whole place is violently hot and bright, all odorous and noisy.

James' description holds good today and is just one illustration of how the unique topography of

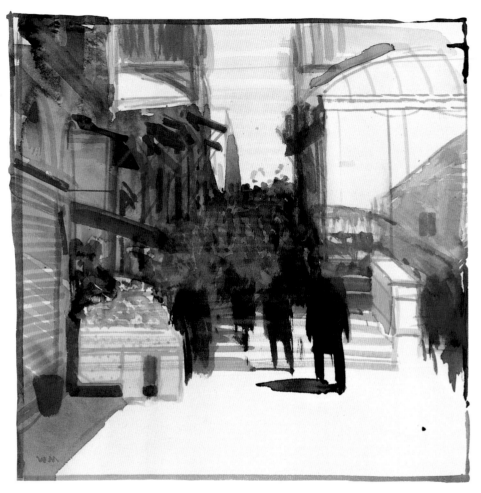

The two studies for the watercolour which are illustrated clearly show how Michael Whittlesea went about developing the design of his picture. The first sketch with colour notes, presumably made on the spot, lays down the broad idea of the picture. It is already apparent that the artist has a clear concept of the final image. The intermediary blue study further analyses the formal and tonal relationships within the composition. In the final work the experiences of both studies are absorbed and expressed in a light and not slavish way – the final expression as fresh as the first.

Michael's innate sense of design has been applied right from the start and there is little sense of the artist struggling with the fundamental structure of his composition. Indeed, this has altered little. It is rather that the detailed arrangement of the various elements has been carefully refined. The array of figures has been tightened up and the whole scene brought into an elegantly economical arrangement, itself enhanced by the delightfully painterly brushwork. The result is a splendid and original evocation of the bustle of Venetian life.

Michael Whittlesea
Study for Rialto Steps
The intermediary study, in which the tonal relationships are clarified

Venice has enabled, or forced its people to retain a way of life long abandoned in other cities. However, the markets were anything but hot when the photograph reproduced here was taken, nor indeed when Michael Whittlesea made the studies for his watercolour. In this work the artist has chosen to approach a familiar subject from a rather unusual viewpoint. It is an angle on the bridge that is familiar to every passing Venetian and tourist alike, but in the height of summer at least, the standpoint it demands of the artist might prove too busy and hazardous for peaceful drawing.

Michael Whittlesea was born in London in 1938 and trained at Harrow School of Art. He worked for some time as an illustrator, but in recent years has increasingly concentrated on painting in watercolour and oils. His range of subject matter is considerable, from landscape and still-life to portraiture and he has exhibited widely. He has also taught, notably at the Berkshire College of Art, and written a successful instructional book on watercolour. Michael, who lives in Berkshire, was elected an Associate of the Royal Watercolour Society in 1982 and in 1985 was promoted to full Membership.

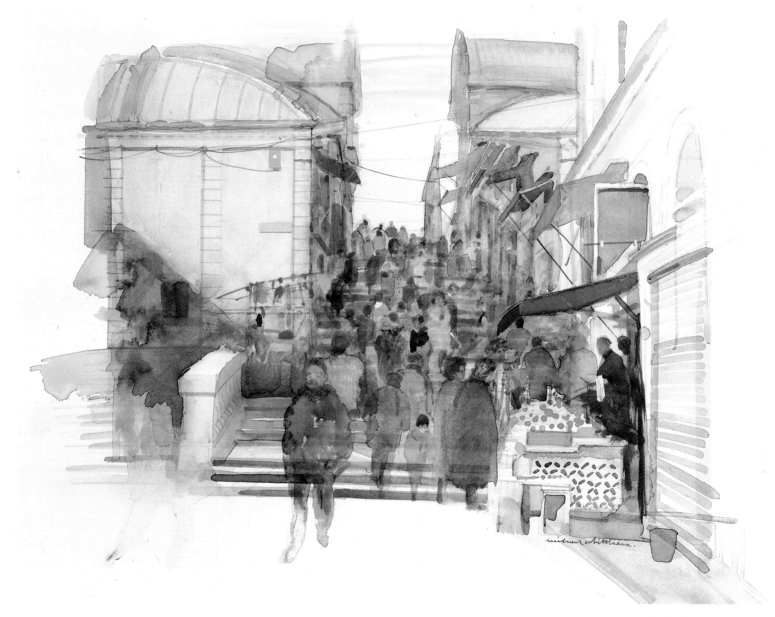

Michael Whittlesea
RIALTO STEPS

LESLIE WORTH

This view of the Piazza is taken from a spot between the Ala Napoleonica, at its western extremity, and Caffe Florian – the historic watering hole set in, and in good weather outside, the arcades of Scamozzi's Procuratie Nuove, which was built between 1582 and 1640. Named after its first proprietor, Florian's opened in 1720 and was patronised by such figures as Byron, Shelley, Trollope and Henry James. On the right of the painting we look past where tables are placed in more clement weather, to the great bulk of the red-brick Campanile di San Marco. This 323ft (98m) high bell-tower was originally erected between the ninth and the twelfth centuries on Roman foundations. These, however, eventually proved insufficient and the Campanile collapsed into a pile of bricks in 1902. The Venetians determined to restore as perfectly as possible the tower from the belfry of which cannons had fought off the Genoese and Galileo had first demonstrated the telescope, and by 1912 it was rebuilt.

Beyond the Campanile we see the west front and domes of the Basilica. This is a view that was somewhat irreverently recalled by Mark Twain in his travel book *A Tramp Abroad*, published in 1897:

I have not known any happier hours than those I daily spent in front of Florian's, looking across the Great Square at it. Propped on its long row of low thick-legged columns, its back knobbed with domes, it seemed like a vast warty bug taking a meditative walk.

This grand and poetical watercolour records a moment on the evening of 3 May 1988 when the visitor might have lost a certain amount of interest in any architectural oddities of the Basilica, but would certainly be aware of the sky. On that day, Venice became as the painter William Etty had experienced it over a century and a half earlier: 'Moored in an immense Raft of a city, with water, water, salt water, everywhere, and at present, plenty of fresh coming down: there is of course – no want of damp.'

Leslie Worth's view is clearly not a work of architectural topography, although a sense of place is essential to the weather effects depicted. His watercolour captures with considerable subtlety and dexterity the aftermath of a Venetian rain storm. The picture recalls so well the smell of rain on warm flagstones, that is a most vivid and sensuous experience of the Piazza San Marco.

With his technical mastery, Leslie has conjured an ethereal record of the scene. As a consummate technician should, he makes the picture-making process look effortless, but this is, in fact, an extremely complicated piece of work. It relies on a complex overlaying of washes on damp paper, with contrasting strokes and dabs onto dry, that help to establish the planes and angles of surfaces and thus the spatial structure of the scene. Each dotted figure and umbrella serves to emphasise the angles of the surfaces and the reflecting wetness of the Piazza.

This watercolour can also be described on another level. There is a comparison to be made here with some of the watercolour sketches of Turner, that were apparently made for his own use and education, and in which the act of painting almost seems to be as important as the end result or the topography of the

The discarded Polaroid photograph that was an inspiration for the artist's watercolour

subject. Fortunately, Leslie does not seem to allow his technical facility to take over and become an end in itself – a piece of picture-making bravura. However, neither is he purely employing his skills to achieve a result in which the creative mysteries of watercolour technique have been hidden.

Turner is clearly much admired by the artist. Both men seem able to discover considerable truths about the world and its climate – often damp – and about painting itself through the very act of image making. A lifetime of studying nature and Turner, of heightening his own perceptions and abilities to express them, have not necessarily made the act a simpler one. However, the process through which Leslie distilled the encounters which led to the making of this particular watercolour indicate the benefit of this experience:

The difficulty in describing the genesis of a work is that to the painter the process is seldom simple. The recollection is confused. The progress, full of hesitation and revision – and it is almost in disbelief that one finally surveys this strange object – incredibly, so it seems – not of our making – and despite all, standing there, from which (hopefully) all signs of struggle have been expunged.

In a side street behind the Rialto the *proprietario* of the café looked up at the strip of blue between the buildings and said,'We shall have a thunderstorm in an hour.'
'Have you heard the weather forecast?' I said.
He smiled indulgently.
'One does not need a forecast when one is a Venetian!' he replied.
Almost to the minute, the sky darkened. We sheltered under an archway as the rain hissed and danced off the paving.

Later as we crossed the Piazza the pools of water were still there. The visitors hurried by with their umbrellas, and the declining sun glanced from the cupolas and mosaics on the western façade of St Mark's.

My eye fell on a small square of card at my feet. I stooped and picked it up. It was a discarded Polaroid photograph of the Piazza. The images were blurred, the smudged block of the Campanile leaned backwards. One could just

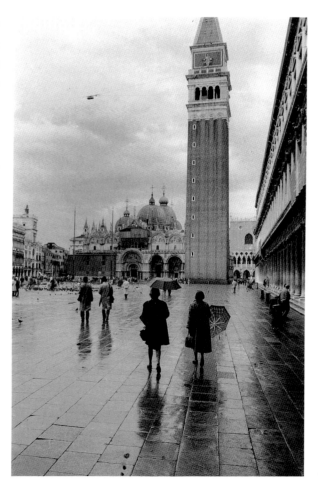

Piazza San Marco after rain

125

discern shapes of figures moving round. Photographically it was a disaster – to me it offered the key to what I had been groping towards.

The painting was done some time later in the studio. Material from various sources contributed. Memories – a nod or two towards Bonington and Turner – other photographs; one tried to keep the central idea intact – not always successfully.

More than one attempt was required. In the end I think it eluded me.

This is my testimony: the judgement is for others.

One can see that Leslie Worth is an artist striving for hard-won truths. If only one could know what it was that eluded hm. Maybe one day he will produce a watercolour and say, 'You know that one of St Mark's Square I did for you? Well, this is rather more what I was trying to get at.'

Leslie Worth was born in Devon in 1923 and studied at the Bideford and Plymouth Schools of Art and then the Royal College. After working as a book designer for Jarrolds of Norwich, he taught at Epsom School of Art, becoming Head of Fine Art. He exhibited his landscapes widely and eventually retired early to concentrate on his work. He has had numerous one-man shows and his work is in the collections of several members of the Royal Family. He has also written on the practice of painting. As Senior Vice President, he has overseen the educational programme of the Royal Watercolour Society, to which he was elected an Associate in 1958 and a Member in 1967. Leslie lives in Surrey.

Leslie Worth
Sᴛ Mᴀʀᴋs Sǫᴜᴀʀᴇ ɪɴ ᴛʜᴇ
Rᴀɪɴ, *detail*

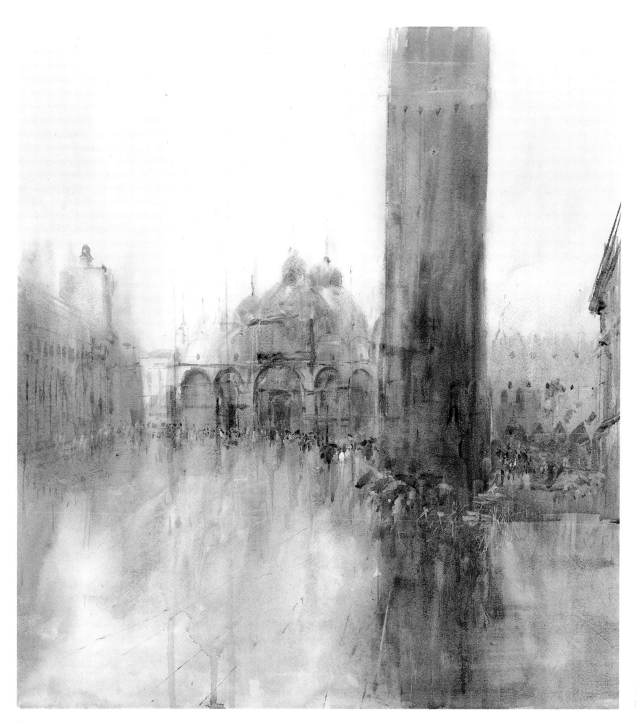

Leslie Worth
Sᴛ Mᴀʀᴋs Sǫᴜᴀʀᴇ ɪɴ ᴛʜᴇ Rᴀɪɴ

SELECT BIBLIOGRAPHY

The following books were available to the author at the time of writing and, it is hoped, will be accessible to the reader.

There have been as many excellent books written about Venice as about any other city. Extensive bibliographies are included in, among others, the works of Christopher Hibbert and Michael Marqusee, mentioned below.

Byron, Lord, *Poetical Works* (Oxford 1970)

Halsby, Julian, *Venice – the Painter's City* (London 1990)

Hibbert, Christopher, *Venice: the Biography of a City,* (London, 1988)

James, Henry, *Henry James on Italy* (London, 1988)

Macadam, Alta, *Blue Guide: Venice* (London 1989)

Marqusee, Michael, *Venice: an Illustrated Anthology* (London, 1988)

Morris, Jan, *Venice* (London, 1974)

Norwich, John Julius, *Venice: The Rise to Empire* (London, 1977) *Venice: The Greatness and the Fall* (London, 1981)

Ruskin, John, *The Stones of Venice*, edited and introduced by Jan Morris (Faber & Faber, 1981)

Salvadori, Antonio, *101 Buildings to see in Venice,* translated by Brenda Balich (Venice, 1987)

Shelley, Percy Bysshe, *Poetical Works* (Oxford, 1921)

Stainton, Lindsay, *Turner's Venice* (London, 1985)

Wilcox, Timothy, *Visions of Venice* catalogue of an historical loan exhibition (London, 1990)

PHOTOGRAPHIC ACKNOWLEDGEMENTS

AND PAGE NUMBERS OF ILLUSTRATIONS. *All photographs are copyright of the respective photographers and/or artists.*

Artist's & Illustrator's Magazine 56
Bany & Cotton 2, 13, 14, 15, 16, 17, 22, 24, 26, 31, 32(r), 33, 34(r), 37, 38, 39, 41, 42(l), 43, 45, 46(l), 47, 49, 50(r), 51, 53, 54(l), 54(r), 55, 57, 59, 61, 65, 66(l), 67, 69, 70(l), 70(r), 71, 73(l), 75(l), 77, 79, 80(r), 82, 83, 85, 87, 89, 90, 91, 96(r), 98, 99, 100(1), 100(r), 101, 102, 103, 105, 107, 108(r), 109(l), 109(r), 114, 115, 119, 121, 122, 123, 126, 127
Begemann, Mrs Wim 72
Binns, Lorna 36(l)
Blissett, Mike 9, 28(r), 30
Bryan, Tony, ARPS 19, 20, 92(l), 92(r), 93, 95
Caffell, Paul 52
Chevis, Michael 124(l)

Cooper, A.C. Ltd 74
Dazeley, Peter 108(l)
Evans, Tom 104
Johnson Ltd, Oscar & Peter 12, 86
Leisure Painter Magazine 68(l)
Rackhams of Lichfield 111
Spender, Michael 6, 8, 11, 18, 21, 23, 25, 29, 34(l), 36(r), 42(r), 46(r), 48, 50(l), 58, 62, 64, 66(r), 68(r), 73(r), 75(r), 76(r), 81, 84(r), 88(l), 88(r), 94, 97, 106, 110, 113(l), 113(r), 116, 117, 120(r), 125
Todd-White & Son, Rodney 35
Wedgewood, Peter W. 84(l)
Williams, Mandy 80(l)